IMAGES
of America

GIG HARBOR

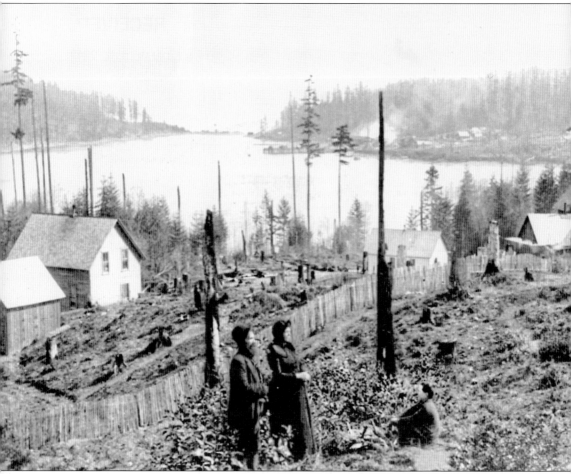

Henry W. and Adeline J. Woodworth are viewing the cleared land and new houses at the head of Gig Harbor in this 1889 photograph. On August 22, 1890, they platted "Woodworth's Addition to Gig Harbor City." Chester Hudson is sitting on the right. The A.J. Bale residence is on the left, and the very first schoolhouse in Gig Harbor is further down the hill. This schoolhouse later became the Peninsula Gateway office. In the background is the Gig Harbor Mill Company. (Courtesy Harbor History Museum.)

ON THE COVER: Taken in November 1926 by the well-known Tacoma photographer Marvin D. Boland, this photograph shows workmen at the Skansie Ship Building Company in Gig Harbor posing with the 180-foot wooden ferry *Defiance*, which is under construction. This ferry had a capacity of 70 cars and made her first run from Gig Harbor to Tacoma on April 3, 1927. (Courtesy Tacoma Public Library.)

IMAGES
of America

GIG HARBOR

Donald R. Tjossem

ARCADIA
PUBLISHING

Copyright © 2013 by Donald R. Tjossem
ISBN 978-0-7385-9602-0

Published by Arcadia Publishing
Charleston, South Carolina

Printed in the United States of America

Library of Congress Control Number: 2012940643

For all general information, please contact Arcadia Publishing:
Telephone 843-853-2070
Fax 843-853-0044
E-mail sales@arcadiapublishing.com
For customer service and orders:
Toll-Free 1-888-313-2665

Visit us on the Internet at www.arcadiapublishing.com

*To all those who have helped make history in the
past and will help make it in the future.*

CONTENTS

ACKNOWLEDGMENTS

Many individuals helped bring this work to completion. A thank-you goes out to the following people, who have contributed in one way or another: Randy Babich, Charles Perry, Al Mashburn, Joy Werlink, Bob Schuler, Pat Nichols, Elizabeth Pederson, Nancy Chryst, Carolyn Marr, Diane Wilder, Jonathan White, Margaret Ensley, Molly Towslee, Jacqueline Auclair, Joanne Brenner, and David Hughes.

Barbara Pearson, researcher at the Harbor History Museum, and Colleen Slater, previous Arcadia author, reviewed the history and helped make the writing flow much better than initially presented to them. Thank you to Coleen Balent of Arcadia Publishing, who initially encouraged me with this project and was a great help. I would also like to thank Arcadia publisher Jeff Ruetsche and editor Jim Kempert for their assistance in helping me bring this book to completion.

From the time of this book's conception, my wife, Becky Alexander, has been a major influence and has been "on call" at all times, available when it was necessary to share an idea or receive input on what was going into the book. She has been supportive, and I would like to thank her for her efforts.

I would like to thank all of the amateur and professional photographers who have recorded these glimpses of history, to be viewed by future generations. Without them, this book would not have been possible and many of the historical events that preceded us may not have been remembered so vividly. They are truly the ones "behind the scenes" and quite often deserve more credit than they are given.

INTRODUCTION

For thousands of years, Native Americans have known of the rich agriculture, hunting, and fishing resources of what was called Twa-wal-kut by the S'Homamish tribe. Their village was located on what we now call Gig Harbor, at the mouth of Donkey Creek. Even when Peter Puget visited in 1792, it appears his party missed the harbor entrance, or at least it was not documented, when they explored southern Puget Sound.

It was not until the expedition of Lt. Charles Wilkes in 1841 that the entrance to the sound was documented. The crew entered the harbor in a longboat used to explore inlets called a captain's gig. This small boat from the *Vincennes* was the first vessel to enter Gig Harbor and lent the body of water its name.

It is reported that three fishermen rowed from British Columbia to Gig Harbor and decided to stay. These men, whose names are familiar to Gig Harbor residents interested in history, were Samuel Jerisich, Peter Goldsmith, and John Farrague. They made their initial settlements in what was the homeland of Puyallup, Nisqually, and Squaxin Indians. According to the 1880 federal census, the three men were listed as fishermen.

When an Indian census was taken of the "Gig Harbor Band" in 1879, it recorded 46 men, women, and children. Growth in the region was slow at first because all transportation to or from the area was by boat. There were no well-defined roads or trails at that time.

Between 1913 and 1930, with the introduction into the region of automobiles, roads, and ferries, the Gig Harbor area began to grow. When the four Skansie brothers founded the Skansie Ship Building Company, Gig Harbor's expansion accelerated. Between 1912 and 1930, the firm is reported to have built more than 100 highly rated vessels.

Farming and poultry were also important in the area. Local farmers joined the Washington Cooperative Farmer's Association and built a large packinghouse in Gig Harbor. In 1918, the first car ferry was started by Pierce County, from Tacoma to Gig Harbor, and this significantly enhanced growth.

After 1921, when Union High School was built, Gig Harbor students no longer had to go to high school in Tacoma. In 1931, a telephone cable was run from Tacoma to Gig Harbor at the bottom of the Narrows, allowing the Island Empire Telephone & Telegraph Company to reach Gig Harbor.

On June 24, 1938, *The Peninsula Gateway* announced, "Narrows Bridge Project Assured." This project was the result of a Public Works Administration grant of $2,700,000. In 1939, work began on the first Narrows Bridge. It was to be the third-longest suspension bridge in the world. It collapsed five months later, on November 7, 1940. The bridge was rebuilt, and the second Narrows Bridge was opened to traffic on October 14, 1950.

The census bureau recorded 803 people in the incorporated area of Gig Harbor for the year 1950 and the last census in 2010 recorded 7,126. Presently, for the three zip codes with a Gig Harbor address, there is an estimated population of about 40,000.

At this writing, the City of Gig Harbor prides itself on a new Community Center, Harbor History Museum, YMCA, Boys and Girls Club, St. Anthony's Hospital, and numerous new commercial developments in the area. The addition of the third Narrows Bridge has made Gig Harbor much more accessible to all in Pierce County and of course gives everyone better ability to commute to Tacoma if necessary.

The future looks bright for Gig Harbor and there is a lot of room for new building and development in the area. Hopefully this book will give the reader a glimpse and an indication of the city's past as we move on into the future. This book has in no way been an attempt to be a comprehensive study of Gig Harbor's past, merely a photographic rendition of what a person may have seen at different times during its history.

One

PIONEERS

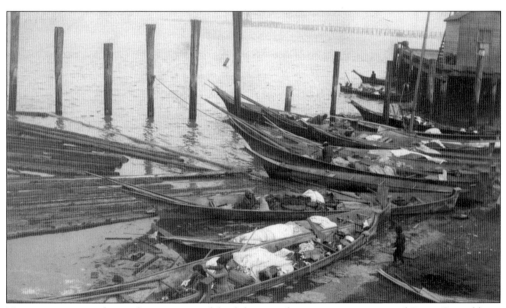

Native canoes similar to these were used for fishing and transportation around Puget Sound long before the explorers of the Wilkes expedition came to the area. The Native Americans were well aware of the good fishing in the Puget Sound and Gig Harbor areas. (Courtesy of the Washington State Historical Society.)

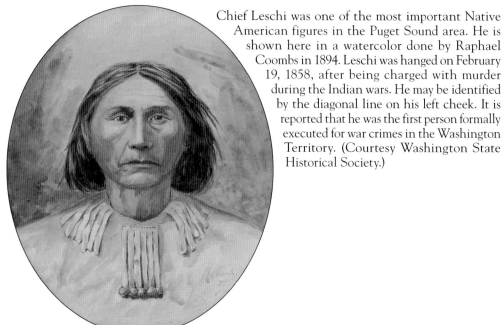

Chief Leschi was one of the most important Native American figures in the Puget Sound area. He is shown here in a watercolor done by Raphael Coombs in 1894. Leschi was hanged on February 19, 1858, after being charged with murder during the Indian wars. He may be identified by the diagonal line on his left cheek. It is reported that he was the first person formally executed for war crimes in the Washington Territory. (Courtesy Washington State Historical Society.)

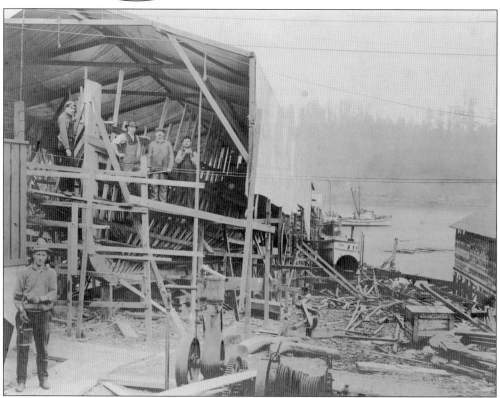

This very early photograph of Skansie Ship Building Company, taken about 1910, shows workers in a cloth-covered structure standing near the hull of a ship. The finished ship *Evelyn* may be seen to the right of the structure. (Courtesy Washington Historical Society.)

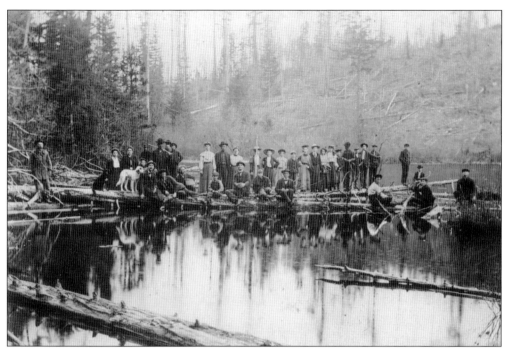

The Joseph and Rose Goodman extended family is pictured here on one of their outings on Crescent Lake. The Goodmans came to Gig Harbor in 1883 and lived at first in a little cabin that Samuel Jerisich had built when he settled in the area. (Courtesy Harbor History Museum.)

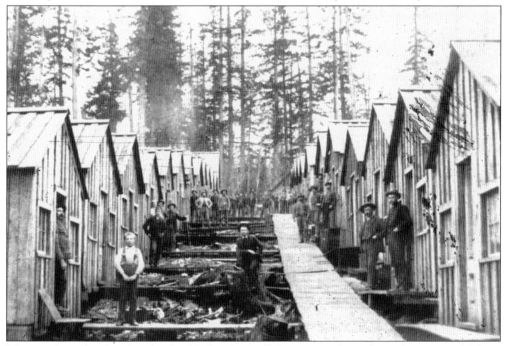

Many early settlers lived in the Gig Harbor Sawmill Company cabins, shown here in 1887. These small cabins, near the present-day Jerisich Dock and Rosedale Street, provided basic shelter for the employees. (Courtesy Harbor History Museum.)

1902

HURRAH FOR
The Fourth

The most Fun for the least money, this year
will be found

AT GIG HARBOR

Speaking, Singing, Shouting,
Racing, Roaring, Rollicking

............ A GREAT............

GAME OF BASE BALL

Between the Clamtwisters of Gig Harbor
and the Unknowns, for the Championship
of the Northwest.

The whole show to wind up with

A Glorious Dance in the Pavillion

PLENTY TO EAT FOR ALL

Steamer SENTINEL Lvs. N. P. Dock

At 8:00, 9:30, 11:30 a. m. and 2:00, 4:00, 6:00 p. m.

This flyer advertises Fourth of July activities in Gig Harbor in 1902, including a dance in the pavilion. Many people would come to this event from Tacoma aboard the steamer *Sentinel*, which would leave from the Northern Pacific Dock. (Courtesy Tacoma Public Library.)

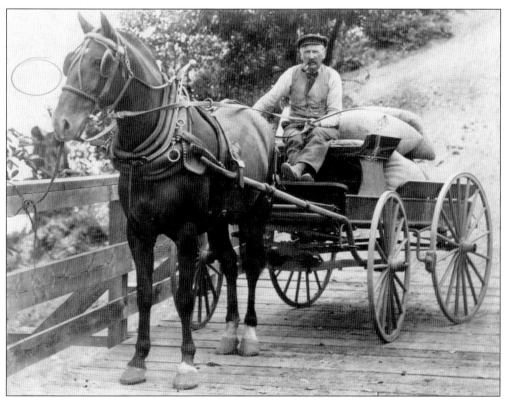

This 1905 photograph shows John Dulin, who settled in the Arletta area of Gig Harbor around 1900. He is shown hauling sacks of feed in a wagon for a grocery and feed store he operated at that time. (Courtesy Museum of History and Industry.)

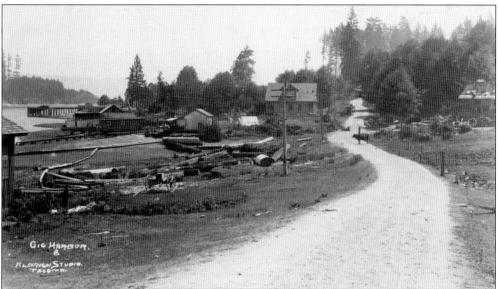

This early photograph of Gig Harbor looks to the east on Harborview Road. The current Harbor History Museum would be on the left side of this photograph. Note the two cows in the middle of the road. (Courtesy Washington Historical Society.)

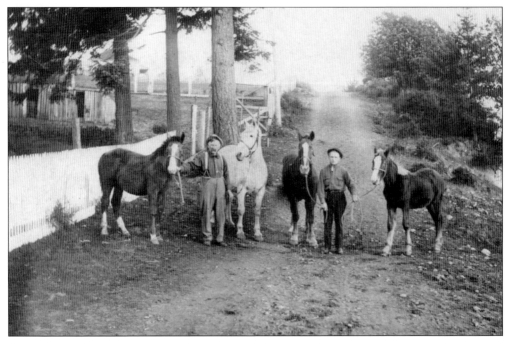

In this 1914 photograph, John Dulin is shown with his son, Ernest, and four horses in the Arletta area. Ernest Dulin was born in 1892 in Wayne, Kansas, before the Dulins moved to Arletta. He passed away in 1959. (Courtesy Museum of History and Industry.)

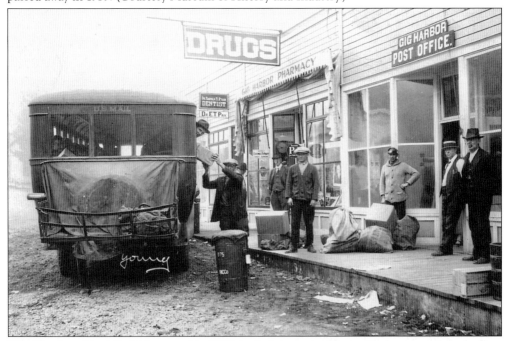

The "Sweeney Block," which opened in 1922, included a post office, café, pharmacy, dental office, and barbershop. Hubert Secor (handling mail from above) and his mail bus, which also carried passengers, are pictured in north Gig Harbor with a delivery for the post office. (Courtesy Harbor History Museum.)

This street scene shows the Sweeney Block and the Finholm area in the early 1920s. Note the vintage vehicles in the photograph. (Washington State Historical Society.)

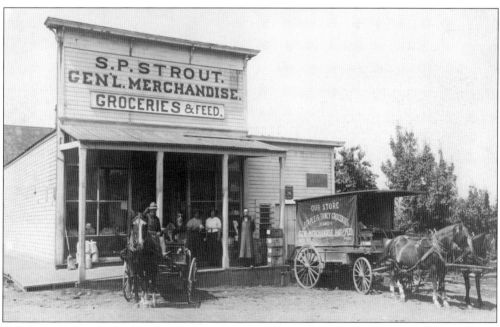

S.P. Strout General Merchandise is pictured here in the early 1900s with a horse-drawn delivery wagon at right. (Courtesy Washington State Historical Society.)

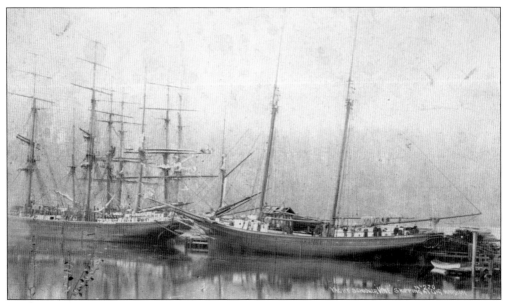

This photograph shows the launching of the schooner *Vine* in 1890 at the shipyard next to the Gig Harbor Lumber Company. Sawmill owners built ships next to the mill so their lumber could be transported throughout the world. (Courtesy the Washington State Historical Society.)

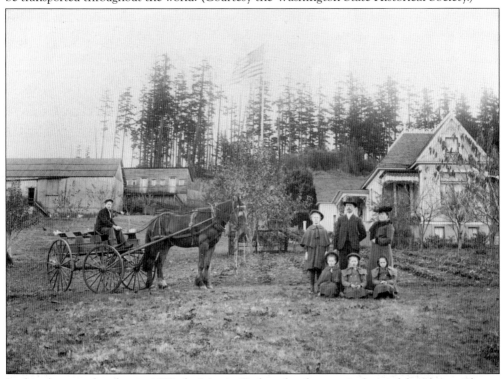

In this photograph, taken in 1903, the Martin Carlson family poses in front of their home. Shown are, from left to right: (kneeling) Elvera, Emma, and Hulda Carlson; (standing) Mary, Martin, and Amanda Carlson; (in wagon) Theodore Johnson. Martin Carlson, a carpenter, built this home, which still stands in east Gig Harbor today. (Courtesy Tacoma Public Library.)

Mitchell Skansie poses with his family in this 1908 photograph. At this time, he was about 28 years old and had recently married Amanda Dorotich (third from right). Mitchell was very active in boatbuilding and fishing and later worked with the Washington Navigation Company, which operated the early Pierce County ferries. (Courtesy Tacoma Public Library.)

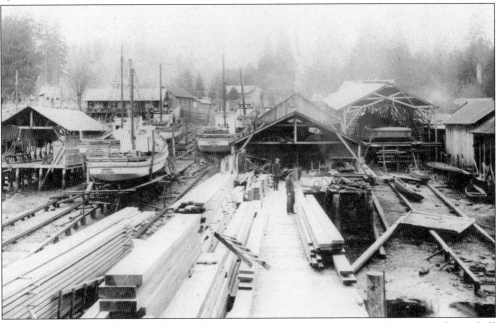

This c. 1915 photograph shows Skansie Ship Building Company in its very early years, with Mitchell (left) and Andrew Skansie (right) on the dock. The shipyard was founded in 1912 by four Yugoslavian brothers: Peter, Mitchell, Andrew, and Joe Skansie. (Courtesy Tacoma Public Library.)

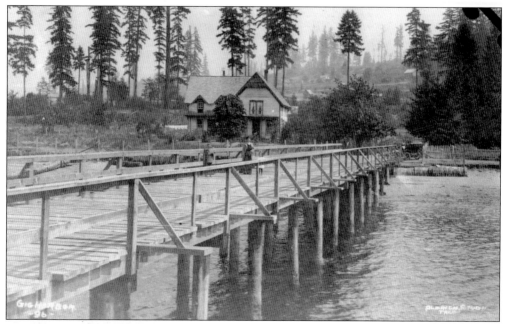

This is Young's Landing, sometimes called Union Dock. Alphonzo Young lived in the house, which served as Gig Harbor's first post office. The Aldrich Studio of Tacoma took this photograph about 1918. (Courtesy Tacoma Public Library.)

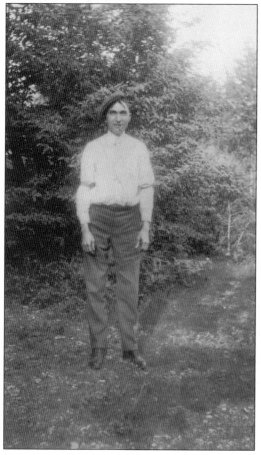

Dr. Samuel J. Ambrose, a longtime resident of Gig Harbor, had a medical practice in Lakewood and advertised himself as a "drugless physician." He and Mary Carlson Ambrose lived in Gig Harbor. In 1929, Dr. Ambrose was listed as the proprietor of the Clover Creek Sanitarium in Tacoma. (Courtesy Tacoma Public Library.)

Shown here are, from left to right, two unidentified women, Bertha, Maria, and Peter Skansie. Maria is Bertha and Peter's daughter. Bertha is Peter's second wife. (Courtesy Randy Babich.)

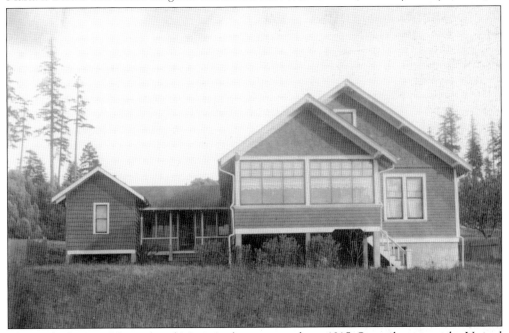

This is the home of Samuel and Mary Ambrose, seen about 1915. Samuel came to the United States from Italy and married Mary Carlson, who was the daughter of Martin and Amanda Carlson. Dr. Ambrose had his offices in the Lakewood area of Tacoma. (Courtesy Tacoma Public Library.)

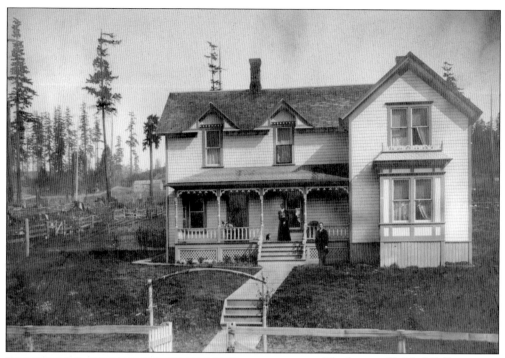

The home of Mabel Iliff is seen here about 1902. From left to right are Hester H. Gilbert (in rocking chair), Ella Iliff, and her father, Maurice Iliff. (Courtesy Tacoma Public Library.)

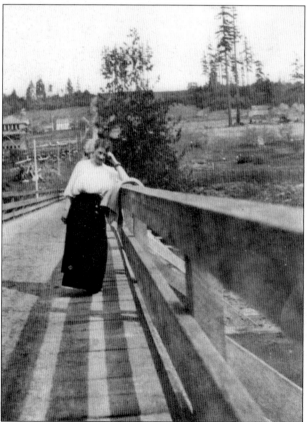

Hulda Carlson stands on the bridge across Crescent Creek about 1915. She was the daughter of Martin and Amanda Carlson, early pioneers of Gig Harbor. (Courtesy Tacoma Public Library.)

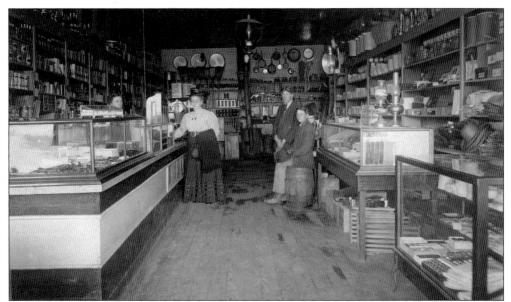

This is the interior of the S.P. Strout Store, a general store in Gig Harbor, in 1909. From left to right in the center of the store are Mrs. S.P. Strout, Emit Ross, and Harry Strout. The woman on the very left, behind the counter, is unidentified. (Courtesy Washington Historical Society.)

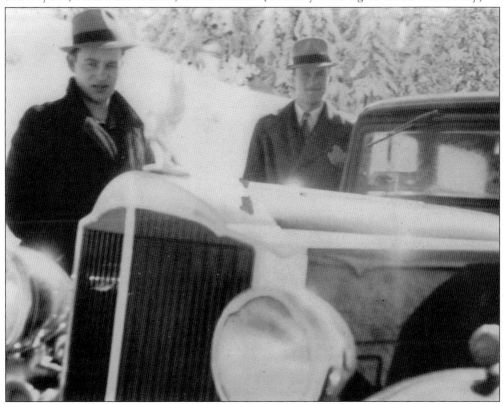

Peter Babich (left) and Paul Babich are great grandsons of Sam and Anna Jerisich. Both Peter and Paul were active fishermen for many years. (Courtesy Randy Babich.)

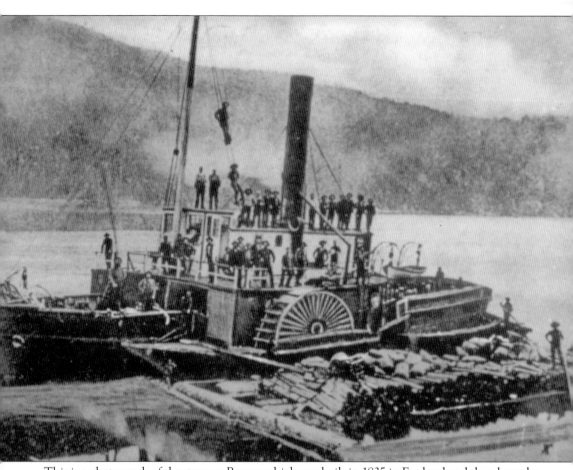

This is a photograph of the steamer *Beaver*, which was built in 1835 in England and then brought around the Straights of Magellan to Puget Sound. This steamer is reported to have been present at peace negotiations with Chief Leschi while he was on Fox Island. McNeil Island was named after William Henry McNeil, captain of the *Beaver*. The ship was active in the Puget Sound area for over 50 years, until it wrecked in Vancouver, British Columbia, in 1888. (Courtesy Harbor History Museum.)

Two

EARLY DAYS

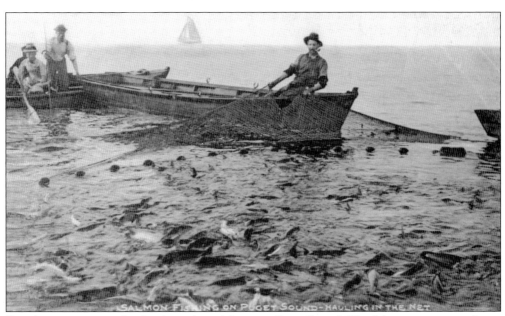

Seen here is an example of early rowboat fishing on Puget Sound. The fish are jumping and nets are being hauled in by hand. Many things have changed as technology has developed in the boatbuilding and fishing industries. (Courtesy Tacoma Public Library.)

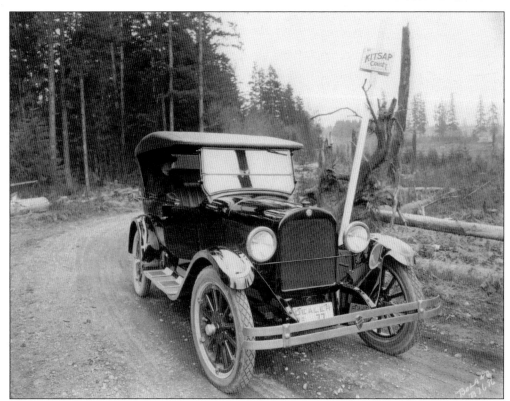

This Dodge touring car is entering Pierce County as it heads to Gig Harbor. It is returning from a promotional tour by the Auto Club of Washington, which advertised the Army-Navy Highway as a means of getting from Point Defiance to Bremerton by way of Gig Harbor. The photograph was taken in the spring of 1923. (Courtesy Tacoma Public Library.)

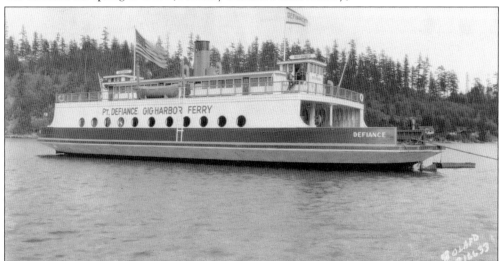

This is the ferryboat *Defiance*, which went between Point Defiance and Gig Harbor. This photograph was taken on April 1, 1927, shortly after she was launched. The new ferry was licensed to carry 500 foot passengers and 30 automobiles. This book's cover shows the *Defiance* while under construction. (Courtesy Tacoma Public Library.)

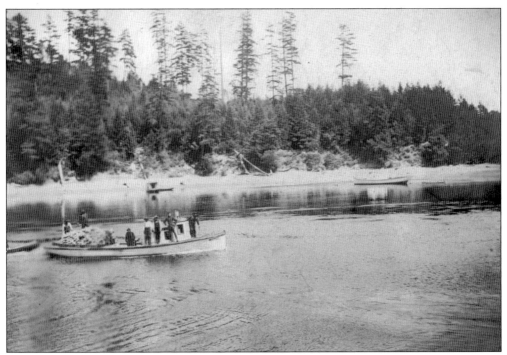

Shown here is an early purse-seining boat in Gig Harbor with a crew of seven. At that time, it took seven fishermen to pull in the nets and fish after a set. (Courtesy Randy Babich.)

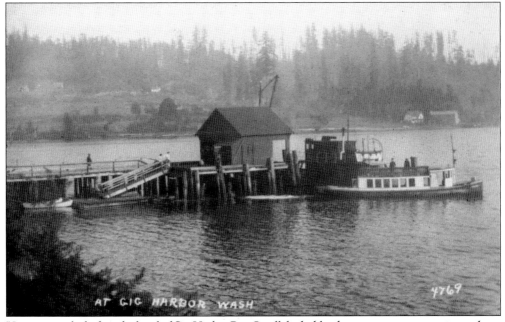

Here is an early dock at the head of Gig Harbor Bay. Small docks like this were very common in southern Puget Sound when water was the main means of transportation. (Author's collection.)

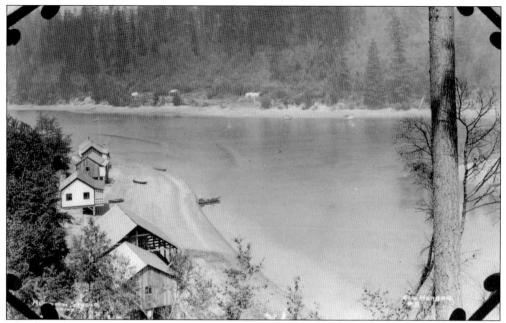

This photograph of the entrance to Gig Harbor was taken about 1918. Note that the houses were built very close to the water and, to allow for high tides, were raised upon pilings. As a result, they did not have basements. (Courtesy Tacoma Public Library.)

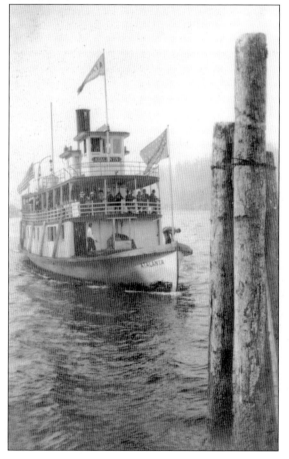

The steamer *Atalanta* is shown heading into Gig Harbor in 1914. This steamer would eventually become the last passenger boat to run on the Tacoma–Gig Harbor route, and had the distinction of being the very first ferry in the south sound to carry cars, even though they had to be hoisted rather than driven aboard. She was only 112 feet long and cruised at a speed of 16 knots. (Courtesy Tacoma Public Library.)

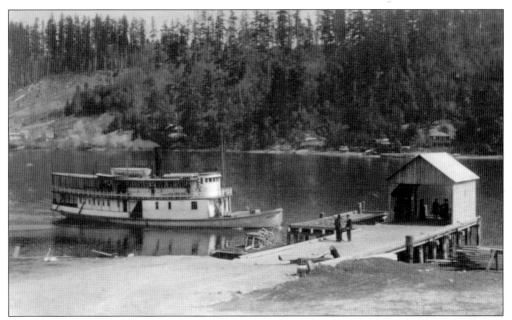

The steamer *Crest* is docking in Gig Harbor about 1918. The craft, built by Gig Harbor pioneer Emmett E. Hunt, was 91.2 feet long and had a 20-foot beam. Her name was later changed to *Bay Island* after she was sold to the Hales Passage & Wollochet Bay Navigation Company. (Courtesy Tacoma Public Library.)

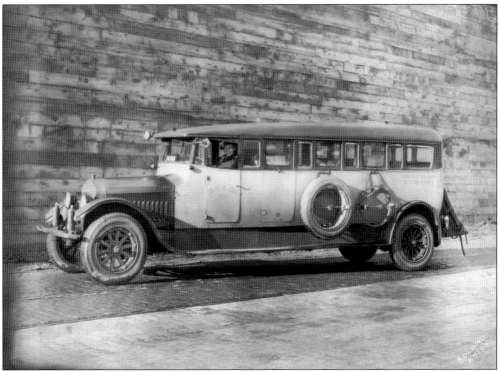

Charles R. Mojean sits in the driver's seat of a Gig Harbor Stage Company bus on January 3, 1923. The 25¢ ticket to Tacoma included the ferry fare. (Courtesy Tacoma Public Library.)

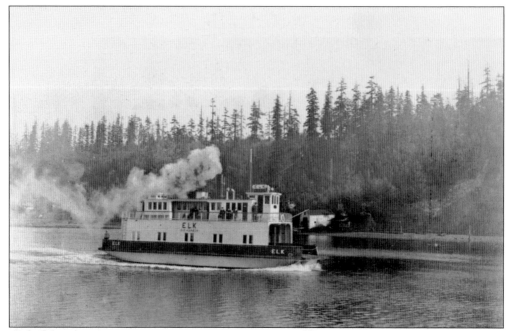

The Gig Harbor ferry *Elk* was built by Skansie Ship Building Company in 1921. This automobile ferry was 67 feet long and could carry up to 16 cars. The *Elk* was used on the Steilacoom–Anderson Island–McNeil Island–Longbranch route while under contract to Pierce County. (Courtesy Tacoma Public Library.)

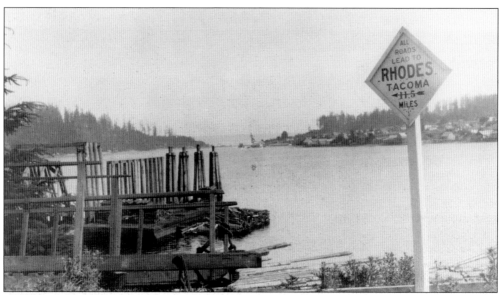

This view from the west end of Gig Harbor shows that "All roads lead to Rhodes, Tacoma, 11.5 miles." Rhodes Brothers Department Store was a major retailer in Tacoma from 1903 until 1974. (Courtesy Tacoma Public Library.)

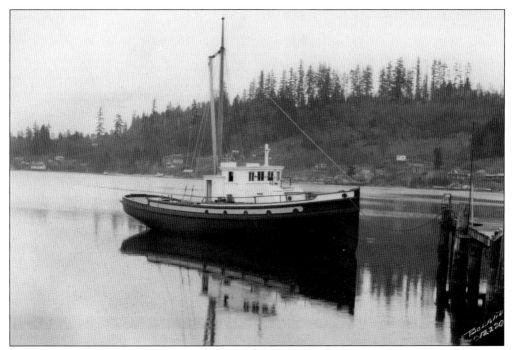

The fishing boat *Shenandoah* is tied up at a dock in Gig Harbor in April 1925. Originally launched the previous week, on March 30, 1925, the boat was built by the Skansie Ship Building Company for Pasco Dorotich. (Courtesy Tacoma Public Library.)

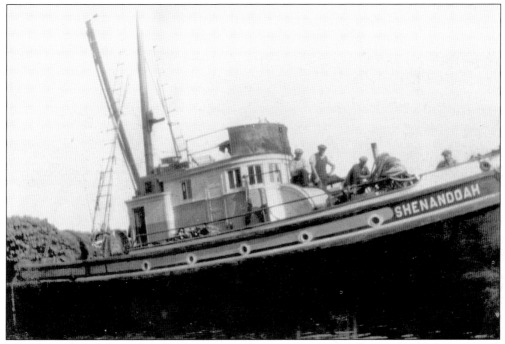

The *Shenandoah*, fully outfitted with nets, is ready to go to sea with full crew aboard. It is currently being restored at the Harbor History Museum by volunteers so that future generations will be able to see what these early fishing boats were like. (Courtesy Harbor History Museum.)

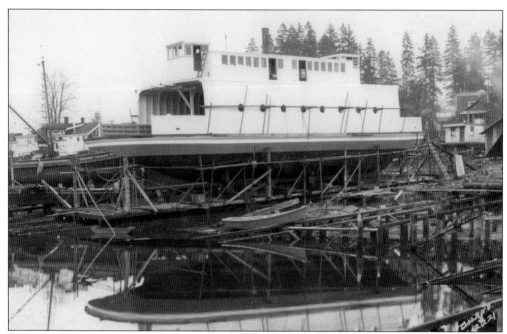

The ferry *Wollochet* is under construction in the Skansie shipyard in April 1925. This 100-foot ferry would service the routes from Cromwell and Fox Island to the Sixth Avenue slip at Titlow Beach in Tacoma. (Courtesy Tacoma Public Library.)

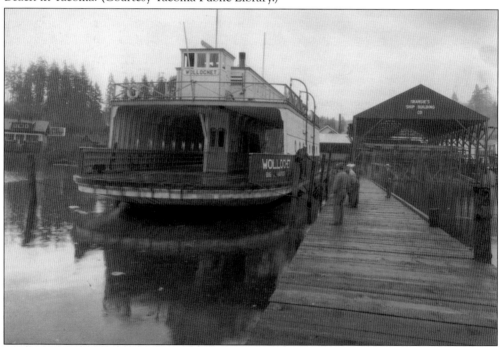

This photograph shows the finished *Wollochet* in November 1926. The boat, 89.5 feet long and 32.5 feet wide, was later named *Fox Island*. She later saw use on the Port Orchard–Bremerton route and then the Port Townsend–Keystone route, after which she was sold to Canadian interests for use in the fishing industry. (Courtesy Tacoma Public Library.)

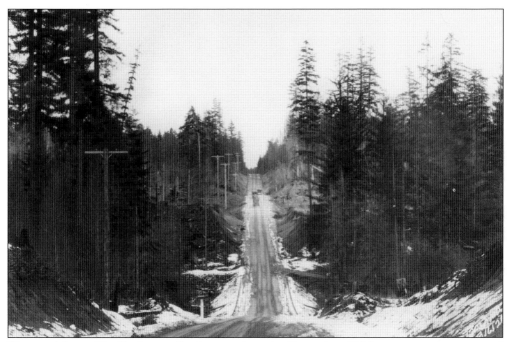

The road from Gig Harbor to Purdy, seen here in December 1926, was narrow, steep, and unpaved. This road preceded the present-day Washington State Route 16. (Courtesy Tacoma Public Library.)

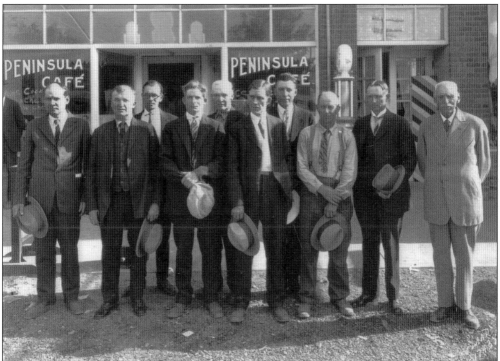

On October 8, 1927, these 10 men removed their hats to pose for a photograph in front of the Peninsula Café in Gig Harbor. (Courtesy Tacoma Public Library.)

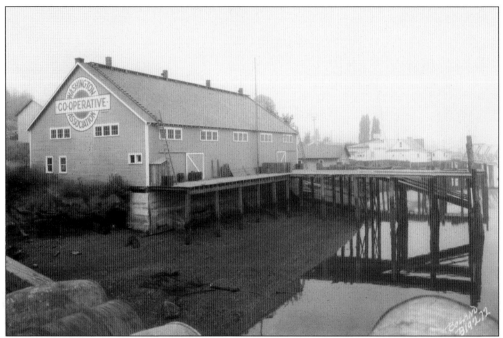

The Washington Cooperative Association's Gig Harbor plant is seen here in the fall of 1928. The egg and poultry association was formed because many of the Puget Sound waterfront towns had to compete with farmers as far away as California and China. (Courtesy Tacoma Public Library.)

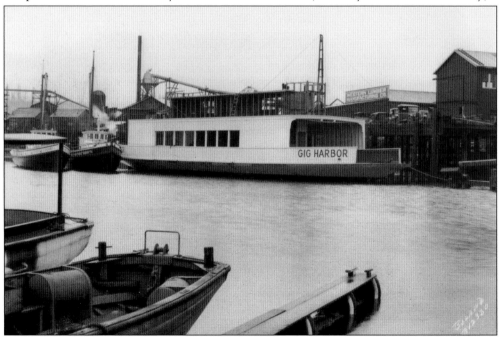

The ferry *Gig Harbor* was, oddly enough, not built by a Gig Harbor shipbuilder, but by the Western Boat Builders Corporation of Tacoma. The 116-foot ferry had the capacity to carry 30 automobiles. This photograph was taken on April 10, 1925, a few days after the ferry was launched. (Courtesy Tacoma Public Library.)

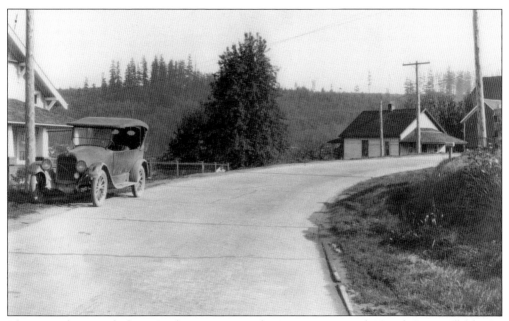

This 1927 photograph shows Harborview Drive where it intersects with Novak Street. The house on the left was the Ancich home, where the US Coast Guard once had its facilities. (Courtesy Tacoma Public Library.)

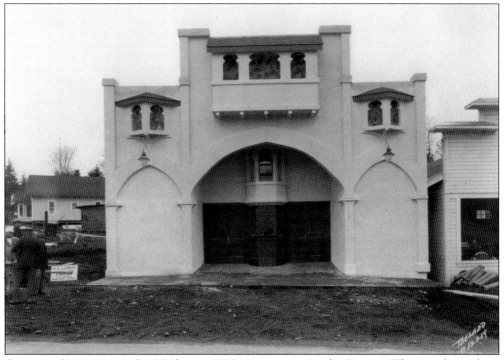

Going to the movies in Gig Harbor in 1925 meant going to the Empress Theater, shown here just a week before it opened, when it featured the silent film *Miss Bluebeard*. The theater had a capacity of 450. After a few name and ownership changes, it was closed in 1955 and was eventually torn down in 1963. (Courtesy Tacoma Public Library.)

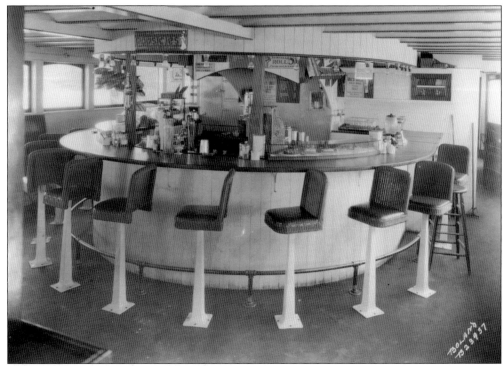

In the 1930s, a commuter ferrying between Gig Harbor and Tacoma would have had time to sit on one of these stools and order a hamburger or hotdog for 10¢, or a ham sandwich for 15¢. This is the counter on the *Skansonia*, which was built in 1929 by Skansie Ship Building Company in Gig Harbor. (Courtesy Tacoma Public Library.)

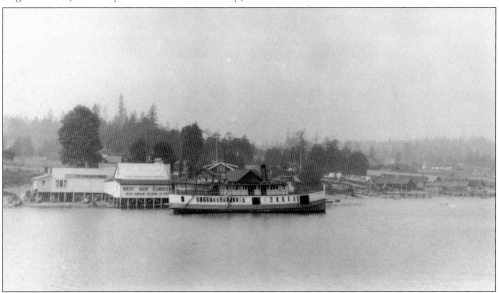

This undated photograph shows the West Side Grocery, currently known as the Tides Tavern. The passenger steamer *Florence K* is docked alongside the Peoples Warf, where small private craft now dock. On the right is part of the Skansie Ship Building Company. (Courtesy Tacoma Public Library.)

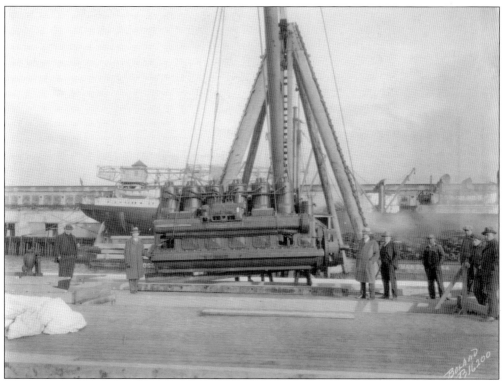

This Fairbanks Morse engine will be placed in the *Defiance*, the Gig Harbor–Point Defiance ferry that had been launched on January 16, 1927. The 360-horsepower engine could push the 70-car ferry at a speed of 10 knots. Employees of the Skansie Ship Building Company pose around the new engine as it arrives at a Tacoma dock. (Courtesy Tacoma Public Library.)

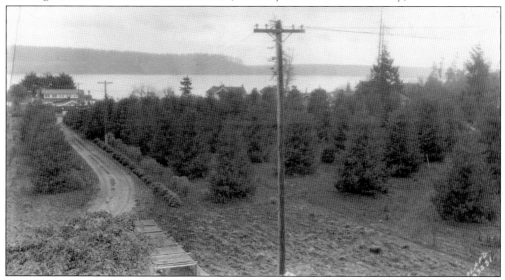

This December 1930 photograph of Soundview Drive shows a Christmas tree and holly farm overlooking the sound. This is part of Hollycroft Gardens, owned by Phillip H. Peyran. He started the nursery in 1914 with 35 holly trees on a 20-acre section of land. (Courtesy Tacoma Public Library.)

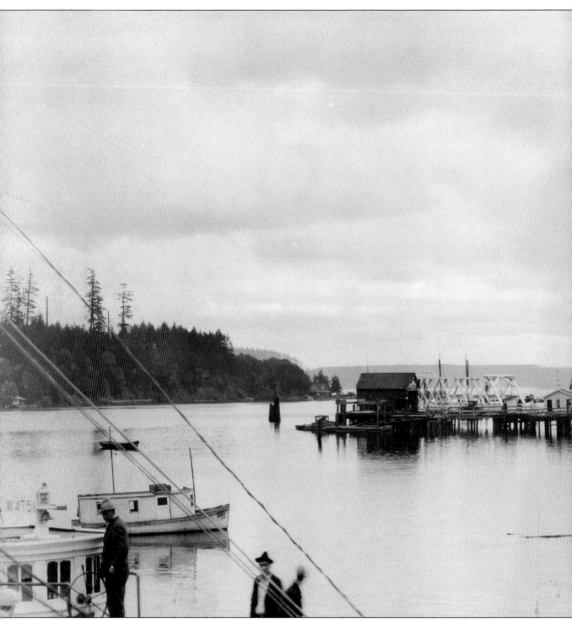

This view of the mouth of Gig Harbor is the left-most third of a panoramic photograph that is continued in the next two images. This section shows the West Side Mercantile Company and the Washington Cooperative Association's plant on January 16, 1927. The West Side Mercantile

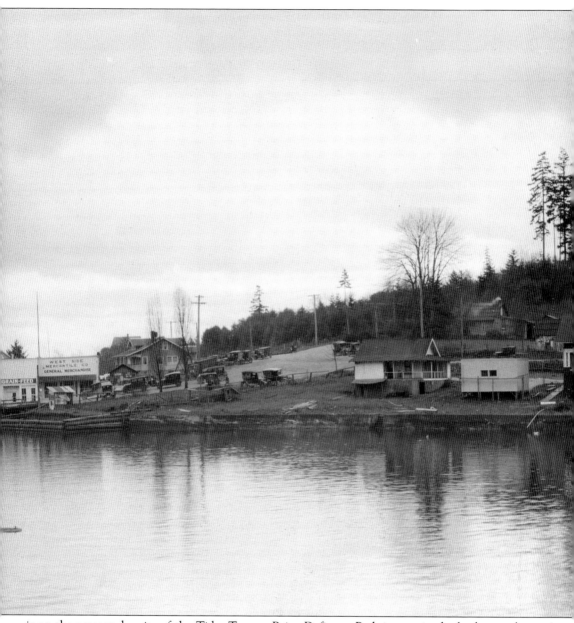

is on the present-day site of the Tides Tavern. Point Defiance Park is seen in the background.
(Courtesy Washington State Historical Society.)

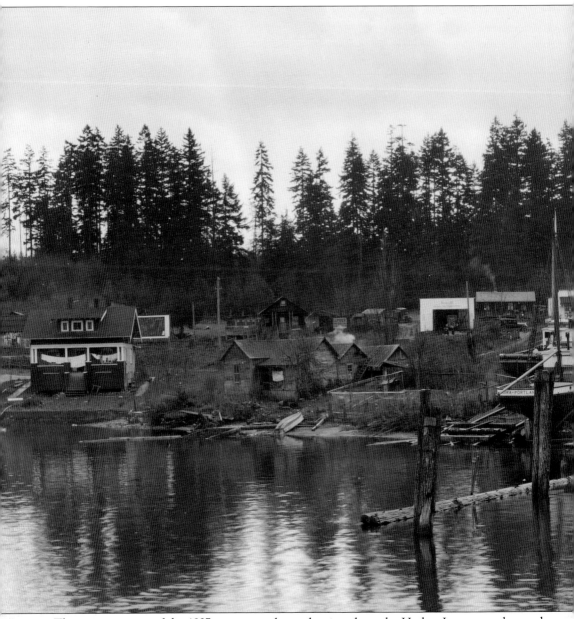

The center section of the 1927 panorama shows the site where the Harbor Inn presently stands (far right), with ships in for repair. Note the former Peninsula Café in the background. A residence

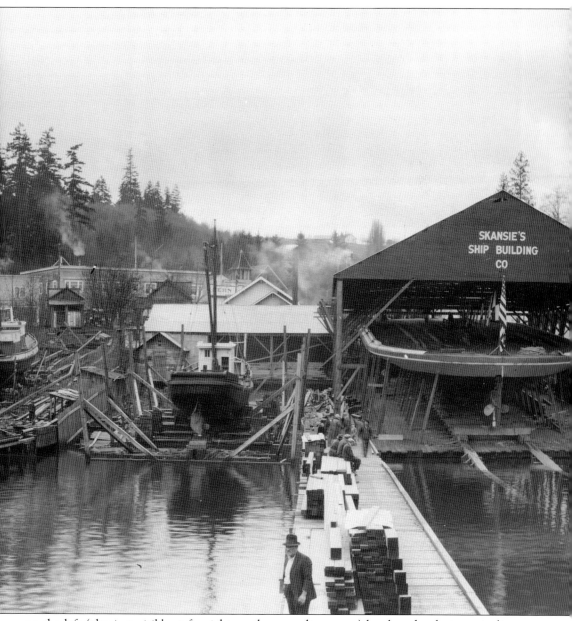

on the left (also just visible at far right on the preceding pages) has laundry drying on a line.
(Courtesy Washington State Historical Society.)

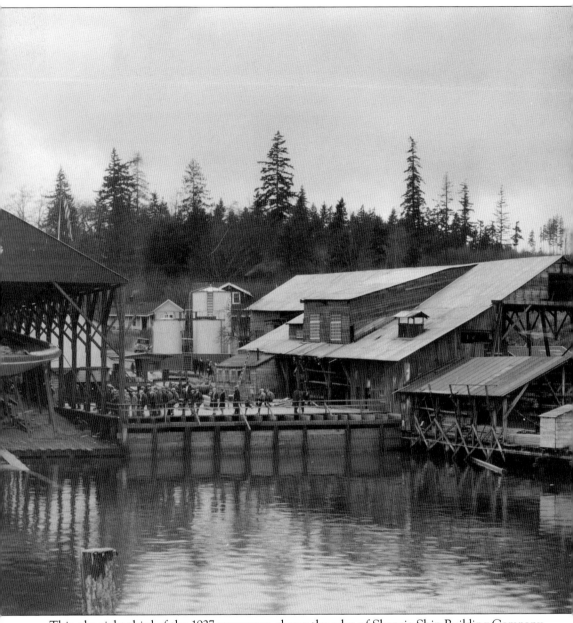

This, the right third of the 1927 panorama, shows the edge of Skansie Ship Building Company on the left, and numerous other docks and net sheds along Harborview Drive. Most of the men

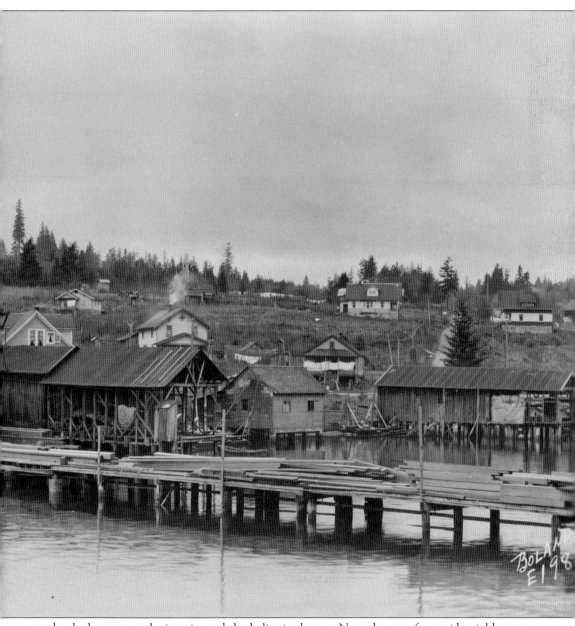

on the dock appear to be in suits and the ladies in dresses. Note the very few residential houses on the hill. (Courtesy Washington State Historical Society.)

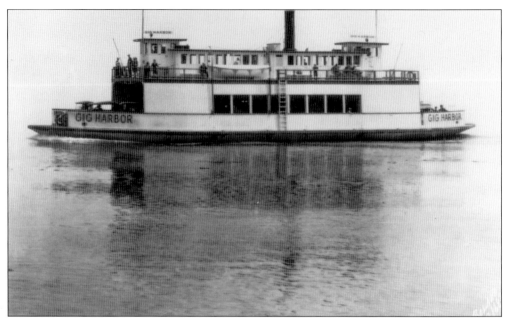

This photograph shows the ferry *Gig Harbor*. Passengers are enjoying the scenery as she makes her way through the calm waters of Puget Sound. (Courtesy Tacoma Public Library.)

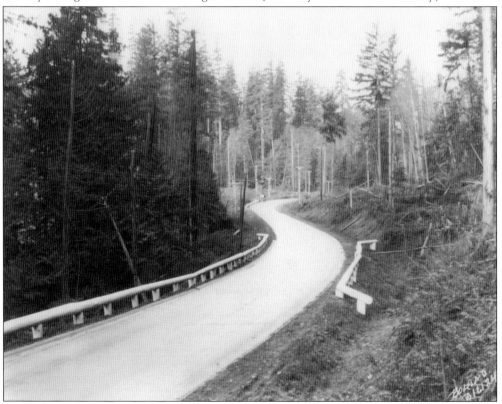

This is part of the Gig Harbor–Purdy Highway as it looked in 1926. Note that this section of the highway is paved and has intermittently placed wooden guardrails. (Courtesy Tacoma Public Library.)

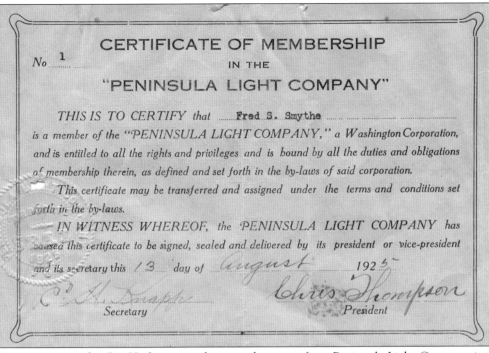

CERTIFICATE OF MEMBERSHIP

No 1

IN THE

"PENINSULA LIGHT COMPANY"

THIS IS TO CERTIFY that Fred S. Smythe

is a member of the "PENINSULA LIGHT COMPANY," a Washington Corporation, and is entitled to all the rights and privileges and is bound by all the duties and obligations of membership therein, as defined and set forth in the by-laws of said corporation.

 This certificate may be transferred and assigned under the terms and conditions set forth in the by-laws.

 IN WITNESS WHEREOF, the PENINSULA LIGHT COMPANY has caused this certificate to be signed, sealed and delivered by its president or vice-president and its secretary this 13 day of August 1925.

Secretary President

Every person in the Gig Harbor area who uses electricity from Peninsula Light Company is a "member." This very first certificate of membership was issued to Fred S. Smythe on August 13, 1925. (Courtesy Peninsula Light Company.)

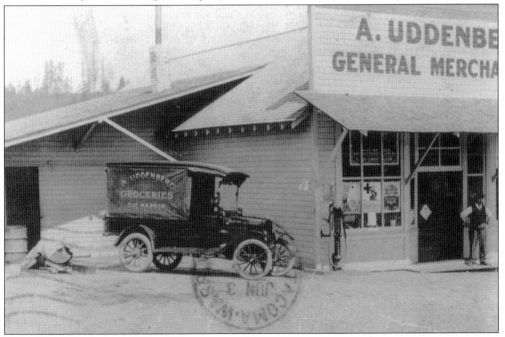

Axel Uddenberg first came to Gig Harbor in 1907. His general merchandise store on the pier at the head of the bay is shown here. The Uddenberg name has been associated with local grocery stores right up to recent times. (Courtesy Harbor History Museum.)

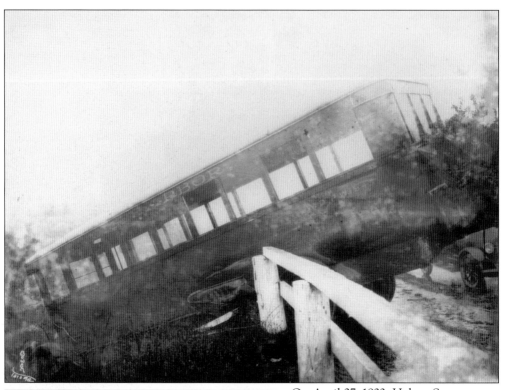

On April 27, 1922, Hubert Secor started a bus service with a single 28-passenger Pierce Arrow bus. The vehicle would carry mail twice a day to Tacoma. For 25¢ plus the ferry toll, a passenger could ride from Gig Harbor. This undated photograph shows what was obviously an eventful day for the driver and any passengers. (Courtesy Tacoma Public Library.)

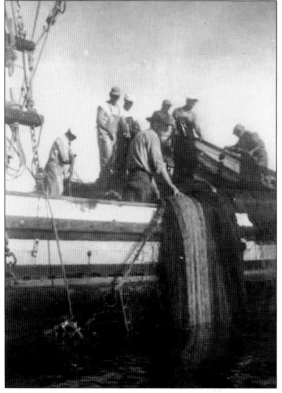

Fishermen aboard the *Welcome II*, owned by John Stanich, are bringing in the nets by hand. This was the standard procedure before the advent of power systems. (Courtesy Harbor History Museum.)

Farming was another important industry to early residents of Gig Harbor. This photograph shows a man and his children bringing in the alfalfa for their livestock. (Courtesy Harbor History Museum.)

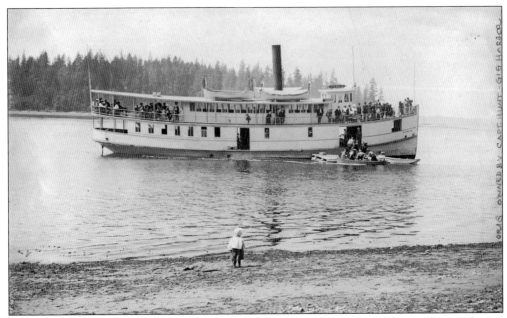

The ferry *Tyrus* made the Tacoma-Allyn run for many years. In this 1904 photograph, a rowboat is either loading or unloading passengers. The *Tyrus* was built by Emmett Hunt of Gig Harbor, and later became the *Virginia IV*, which wrecked in 1935. (Courtesy Washington Historical Society.)

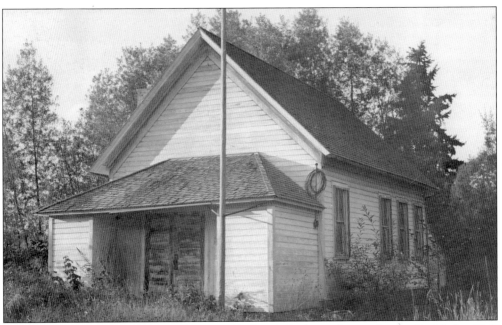

This is Artondale School, which was eventually demolished to make way for the Gig Harbor Golf Course. The school, which closed in 1939, stood pretty much as it appears here until after 1958, when it was destroyed. (Courtesy Peninsula School District.)

Three

ACTIVITIES

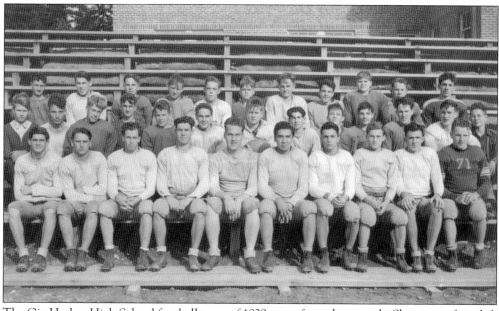

The Gig Harbor High School football team of 1939 poses for a photograph. Shown are, from left to right, (first row) George Gilreath, John Swenson, John Peterson, Donald Ribbe, Coach Einar Husby, Elmer Skahan, Roland Spadoni, Melvin Johnson, Jack Finnigan, and Donald Reed; (second row) Christian Wally (manager), Bill Wight, Marvin McCartney, Bert Perry, Bill Parrish, Robert Ryan, Donald Sehmel, James Russo, Jack Wagner, Bill Hayes, Douglas Stremme, Glen Perkins, and Edgar Best; (third row) Frank Foutch, Francis Hahn, Ray Edwards, John Bowman, Warren Watson, Harry Reed, Charles Parkman, Preston Challender, Howard Reed, Roland Adolphson, and Richard Brown. (Courtesy Tacoma Public Library.)

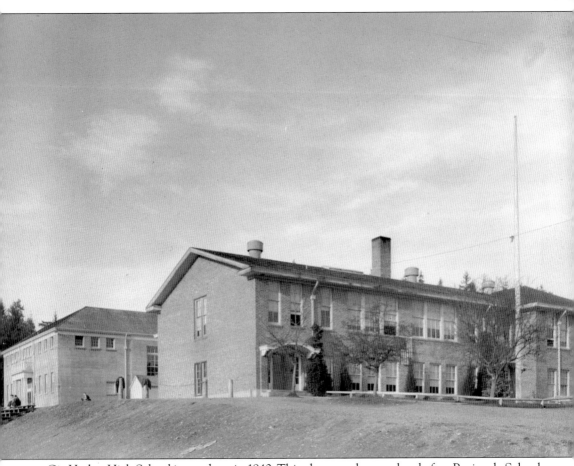

Gig Harbor High School is seen here in 1940. This photograph was taken before Peninsula School District No. 401 came into existence. (Courtesy Tacoma Public Library.)

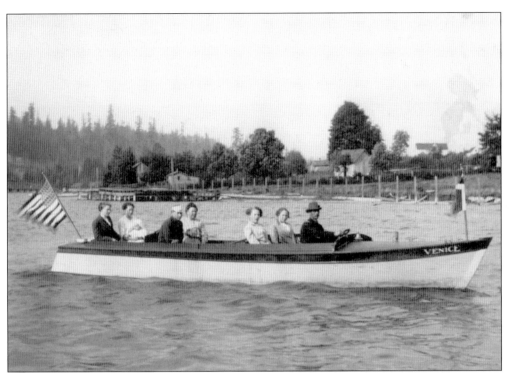

This c. 1912 photograph shows a party of eight aboard the *Venice*. The accompanying caption for the image, which is in the Carson-Ambrose Collection in the Tacoma Public Library, indicates that this is "Sam's Motor boat." It may have been Dr. Samuel Ambrose's boat. (Courtesy Tacoma Public Library.)

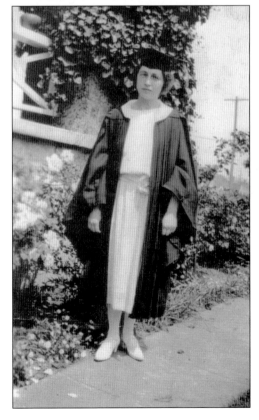

Hulda Carlson poses at home in her cap and gown after graduating from the University of Washington in 1922. Her parents, Martin and Amanda Carlson, emigrated from Sweden and were among the earliest settlers in Gig Harbor. (Courtesy Tacoma Public Library.)

This flyer advertised the Peninsula Fair and Poultry Show for September 7–9, 1928. A special prize was awarded to the couple who were married on the fairgrounds on Sunday, September 9. (Courtesy Washington Historical Society.)

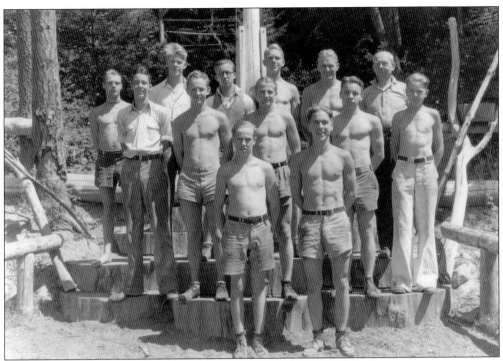

These young men were attendees at the YMCA boys' camp at Camp Seymour in 1931. This popular summer camp, located near Gig Harbor at Glen Cove, has been in operation since 1907. (Courtesy Tacoma Public Library.)

Shown standing are, from left to right, Bertha Skansie, Julia Skansie, unidentified, and Peter Skansie. Lying in front is Lois Babich. (Courtesy Randy Babich.)

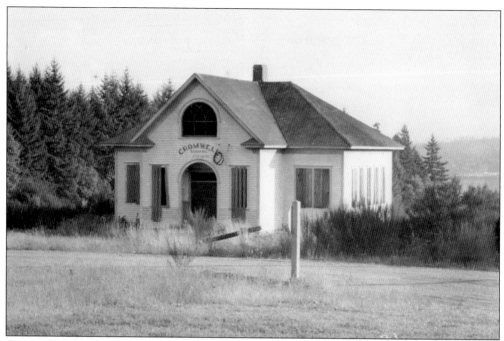

Cromwell School, seen here in 1911, was named for John B. Cromwell, former postmaster of Tacoma. (Courtesy Peninsula School District.)

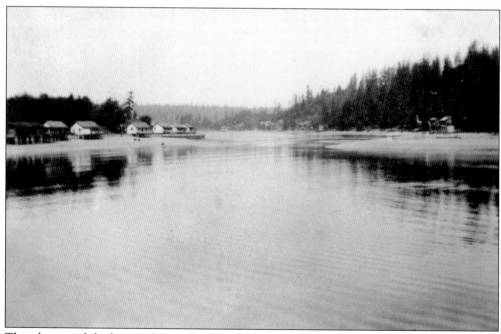

This photograph looks into Gig Harbor from Puget Sound. The houses at left are on piers above the beach. The east side sandspit on the right is the site of the present-day lighthouse. (Courtesy Tacoma Public Library.)

Peter and Paul Babich are seen here with their dog, Lassie, about 1934. Peter and Paul were fishermen and sons of Spiro and Julia Babich. (Courtesy Randy Babich.)

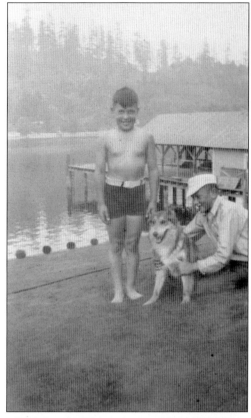

This 1931 photograph of young boys was taken at YMCA Camp Seymour at Glen Cove. Announcements of general interest were made daily by the counselor (far right) while the campers stood in formation. (Courtesy Tacoma Public Library.)

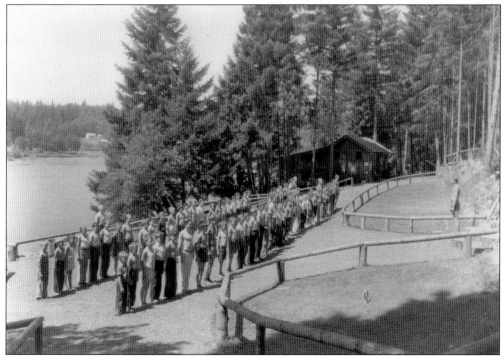

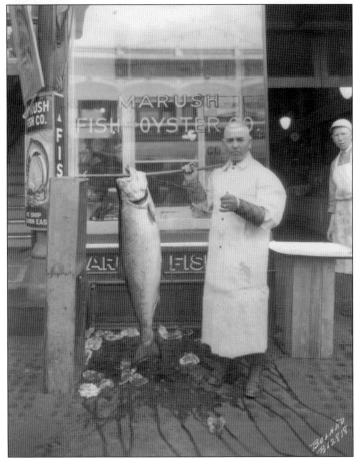

Lincoln School, shown here in the 1950s, was located on Dorotich Street in west Gig Harbor. (Courtesy Peninsula School District.)

G.C. Crawford of Gig Harbor caught this king salmon at the mouth of the harbor. The fish was believed to be the largest ever caught locally on hook and line. Mike Marush poses with it in front of the Marush Fish Company in Tacoma. The huge fish, dressed out weighing 47 pounds, was caught in June 1925. It is reported that the fish fought for nearly an hour. (Courtesy Tacoma Public Library.)

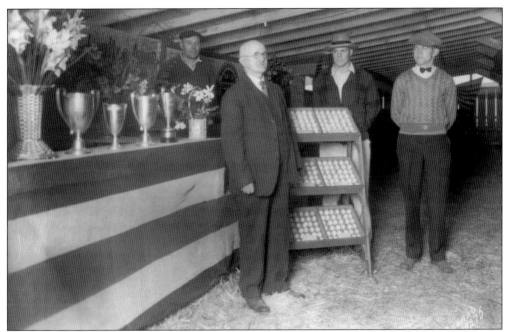

At the 1928 Gig Harbor Fair, Oscar H. Swanson (second from left), founder of the Gig Harbor Washington Cooperative Association, is shown with three other men next to a display of eggs and an array of trophies to be awarded to the winning entries. At this time, the poultry and egg business was a major industry in the peninsula area. (Courtesy Tacoma Public Library.)

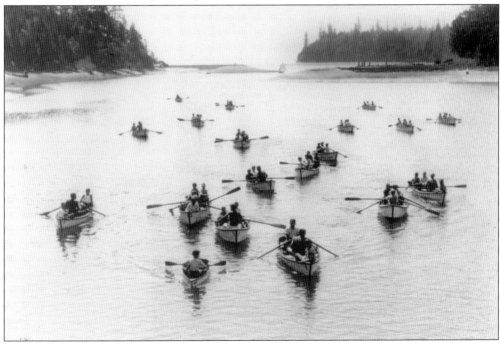

This flotilla of rowboats in Glen Cove is filled with summer campers from the YMCA Camp Seymour on the Key Peninsula. At the time this photograph was taken, it was a boys' camp, but it now admits both boys and girls. (Courtesy Tacoma Public Library.)

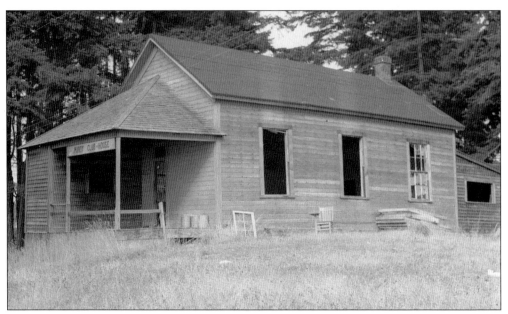

The sign on the front of this building reads "Purdy Club House." In fact, this was originally the Purdy School building, erected about 1898. (Courtesy Peninsula School District.)

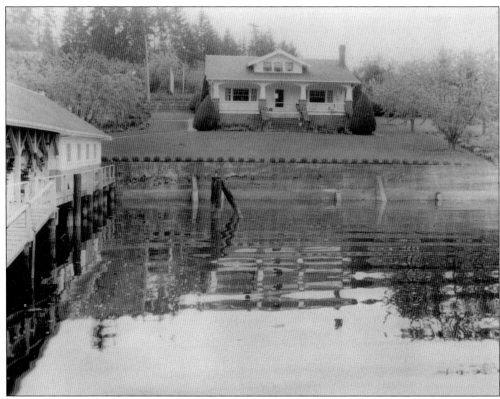

This is the Gig Harbor residence of Spiro Babich. In true fisherman's tradition, the front of the house faces the water. This home was later owned by Peter Babich. (Courtesy Randy Babich.)

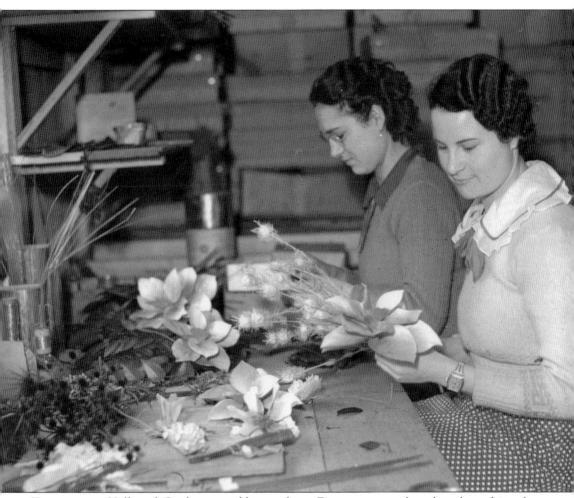

Two women at Hollycroft Gardens assemble rare plants. For many years, plants have been shipped around the world from the Gig Harbor area. (Courtesy Tacoma Public Library.)

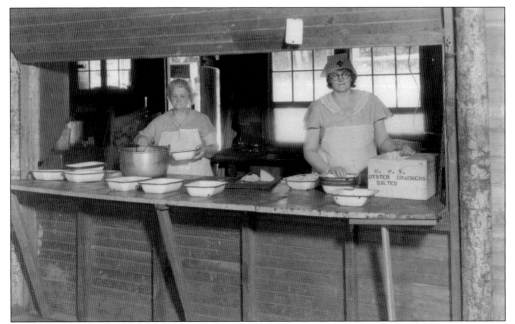

In the summer of 1931, two cooks at Camp Seymour are ready to serve a lunch of oyster stew and crackers to the boys attending the YMCA camp. The former mayor of Tacoma, William W. Seymour, donated this 150-acre camp near Gig Harbor to the YMCA. (Courtesy Tacoma Public Library.)

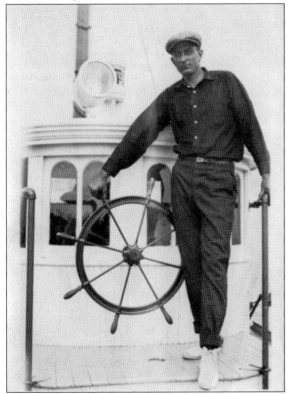

Peter Skarponi is shown here at the helm of an unknown boat. Skarponi may be best remembered as the owner of the *Sea Rose*. The 70-foot purse seiner, launched on January 8, 1949, was built especially for Alaska fishing. (Courtesy Randy Babich.)

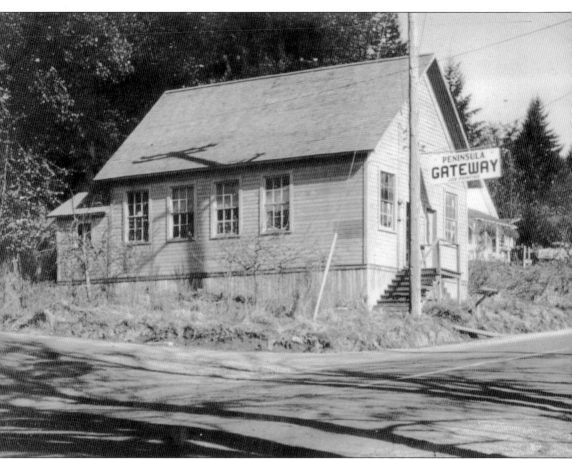

This early photograph shows the office building of the *Peninsula Gateway*, Gig Harbor's weekly newspaper. The building was originally part of the Gig Harbor school system. (Courtesy Harbor History Museum.)

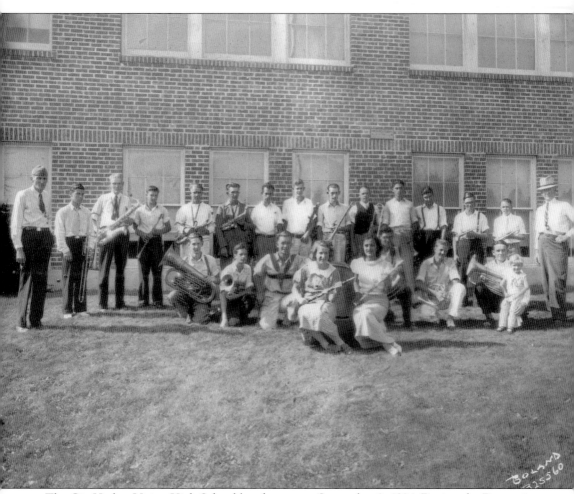

The Gig Harbor Union High School band poses on September 2, 1934. During the Depression and prior to the construction of the first Narrows Bridge, travel for a high school band was not as extensive as it is now. (Courtesy Tacoma Public Library.)

In 1938, the Works Progress Administration financed and built the Arletta School. The building later became the Hales Pass Community Center. On February 1, 2011, it was acquired by the PenMet Parks from Pierce County. It is currently in what is called Hales Pass Park, a 3.8-acre public park. (Courtesy Peninsula School District.)

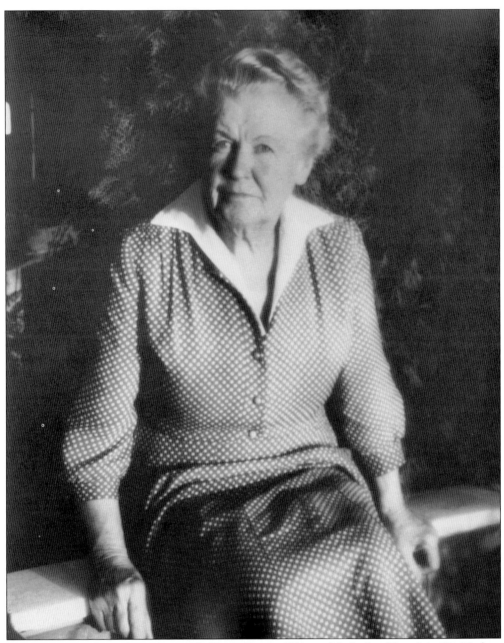

Agnes Hansson, shown here, married L. Henry Foss in 1914 in a Methodist Church in Gig Harbor. The couple made their first home in a cookhouse next to the Foss Launch and Tug Company in Tacoma. Henry Foss became the major builder of the Tacoma fleet and tug operation of Foss Launch & Tug Company. He eventually retired from the US Navy with the rank of rear admiral. The Fosses were married for 65 years. (Courtesy Tacoma Public Library.)

Four

EARLY COMMERCE

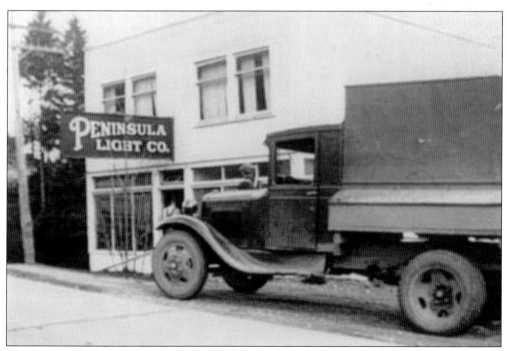

The Peninsula Light Company office was located here from 1925 to 1964. This site is at the mouth of Donkey Creek, just above the current Harbor History Museum. (Courtesy Peninsula Light Company.)

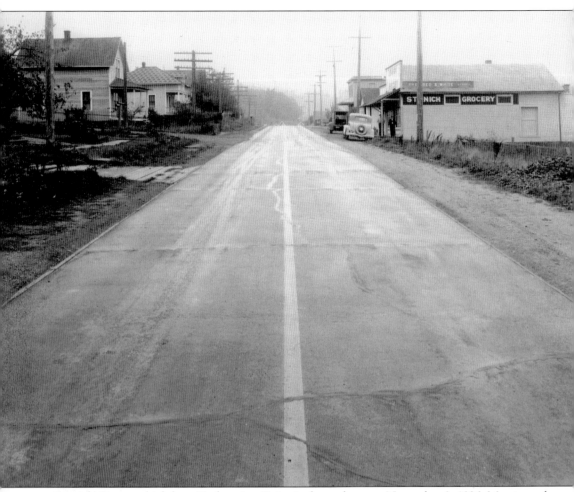

Stanich Grocery (right) on Harborview Drive is shown here on November 3, 1936. Martin and Katherine Stanich were Yugoslavian settlers in Gig Harbor. Martin was a retired fisherman when he opened a grocery store that belonged to the Red & White chain of stores. (Courtesy Tacoma Public Library.)

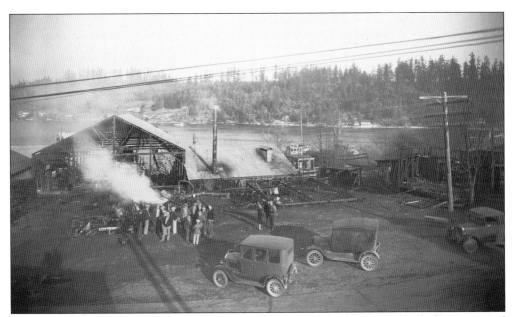

A hotel and store fire took place on January 12, 1930. The buildings overlook the water, and several vehicles are visible in the foreground. (Courtesy Washington Historical Society.)

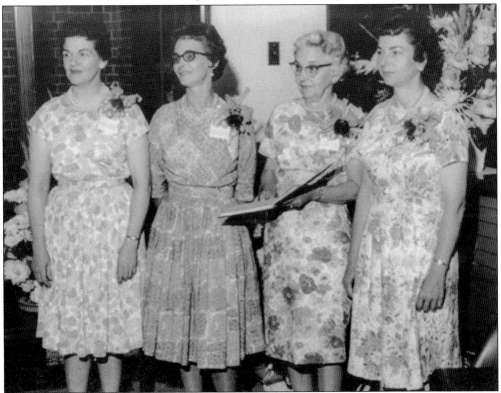

In 1964, Peninsula Light Company opened its new building. Shown here at the open house are, from left to right, employees Lorraine Lindstrom, Alice Krotzer, Mable Dillon (holding guestbook), and Fay Fields. (Courtesy Peninsula Light Company.)

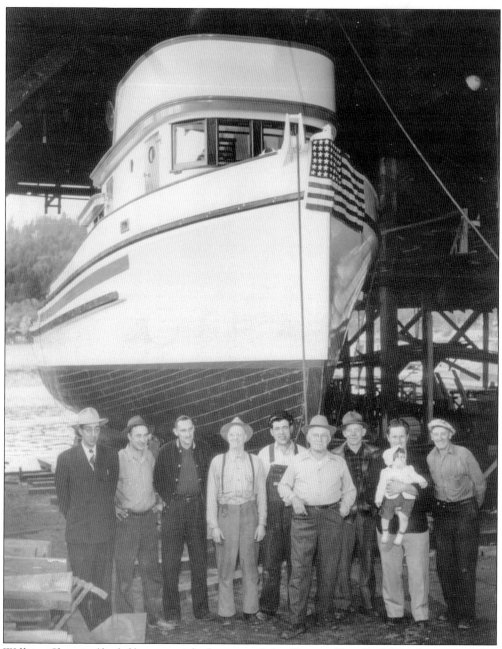

William Skansie (far left) poses with the crew of the Skansie Ship Building Company. John Cosulich (sixth from left) had been a supervisor for the company for 37 years. This yet-unnamed seiner was completed in April 1949 and was the first fishing boat to be built in the shipyard since 1930. (Courtesy Tacoma Public Library.)

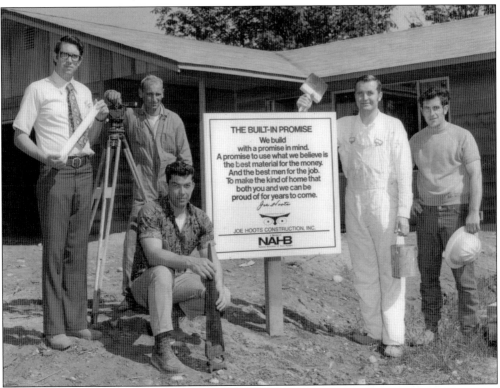

These workmen pose with a sign attesting to the "Built-In Promise" of Joe Hoots Construction. Hoots was a longtime Gig Harbor resident and activist. (Courtesy Tacoma Public Library.)

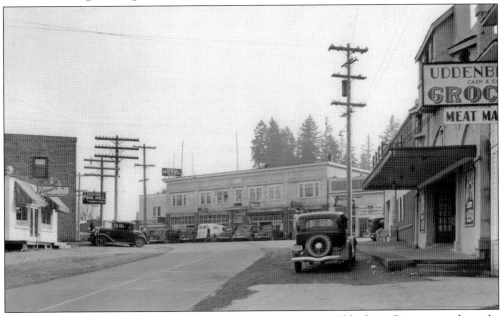

This 1940 photograph of Gig Harbor's business district shows Uddenberg Grocery on the right and, next to it, the Roxy Theatre. Also visible are the Peninsula Hotel, Pastime Pool Hall, and Elinor's Fountain. (Courtesy Tacoma Public Library.)

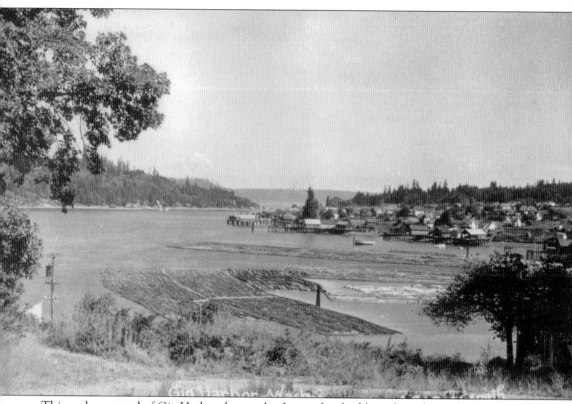

This early postcard of Gig Harbor shows a log boom that had been brought to the Austin Mill for processing. Log booms have not been allowed and have not appeared in Gig Harbor for a very long time. (Author's Collection.)

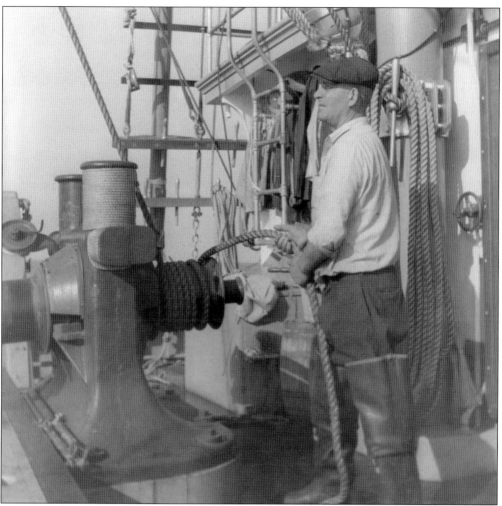

This c. 1940 photograph shows Spiro Babich handling a hemp line while fishing. Babich was known for changing boats almost yearly, so the name of this particular vessel is unknown. (Courtesy Randy Babich.)

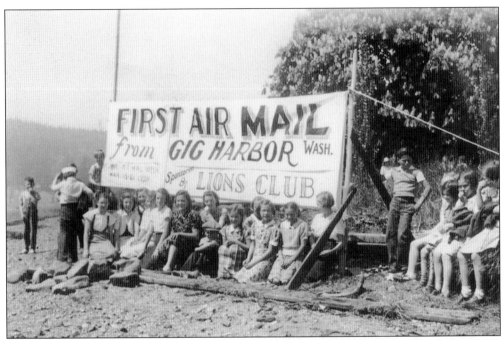

Airmail flew into and out of Gig Harbor during a special promotion in the week of May 15–21, 1938. Since there was no airport at the time, the plane landed on the beach on the east side of the harbor. On May 19, a total of 1,278 airmail letters postmarked "Gig Harbor" were dispatched. (Courtesy Harbor History Museum.)

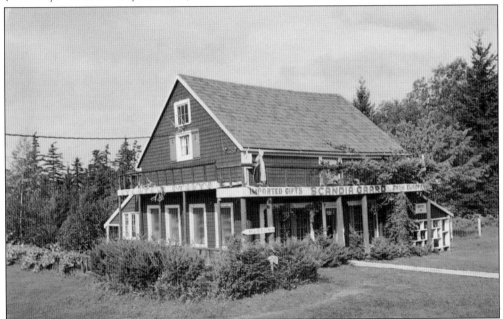

Seen here is the original Scandia Gaard, on top of Peacock Hill overlooking Gig Harbor. The building shows its Scandinavian influence. At the time, it had only a Nordic museum and a Scandinavian coffee shop. It later expanded to house a restaurant before it was destroyed by fire in 2006. (Author's collection.)

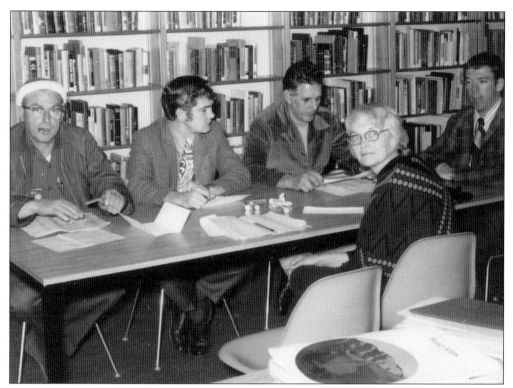

A Gig Harbor city council study session is being held in 1969. Shown are, from left to right, Edward Bunch, Gary Stainbrook, Jack (Jake) Bujacich, Ruth M. Bogue, and Dennis Courtright. (Courtesy City of Gig Harbor.)

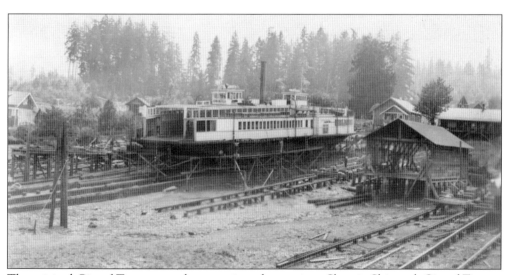

The original *City of Tacoma*, on the ways, is under repair at Skansie Shipyard. *City of Tacoma* began ferry service from the head of the bay in Gig Harbor in 1917. (Courtesy Washington State Historical Society.)

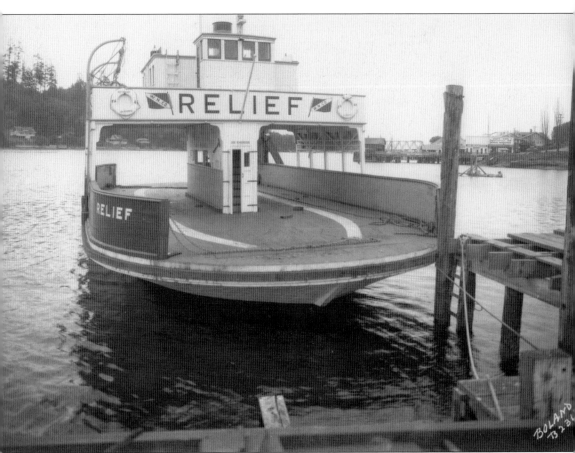

The Washington Navigation Company ferry *Relief* is docked at Gig Harbor. This ferry, launched on July 17, 1930, at Skansie Shipbuilding, was 72 feet long, had a 32-foot beam, and was propelled by an 85-horsepower diesel engine. The name *Relief* refers to the fact that the boat relieved other ferries when they were out of service. (Courtesy Tacoma Public Library.)

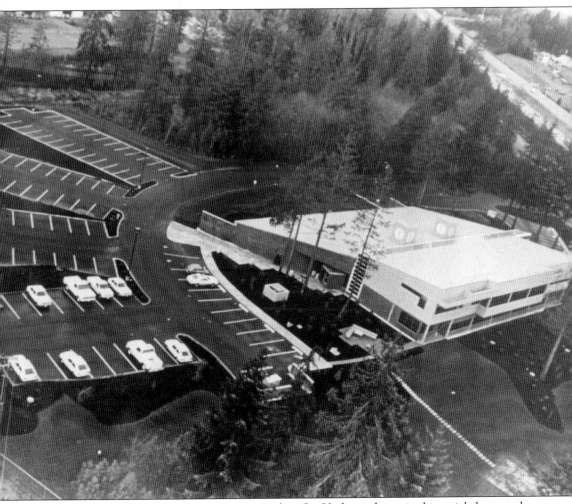

What is now the building that houses CenturyLink in Gig Harbor is shown in this aerial photograph taken just before the building was fully utilized and opened in 1984. At that time, the phone company was called Pacific Telephone. It is located at 8109 Skansie Avenue and is very visible from Highway 16. (Courtesy CenturyLink.)

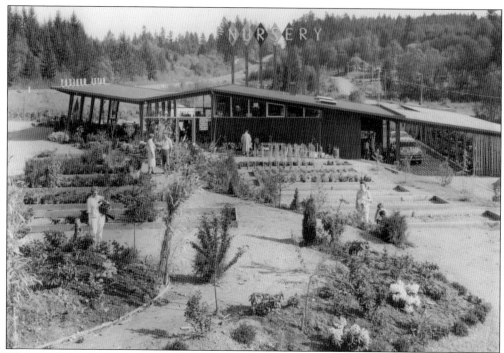

The new Eric Hayes Nursery displays plants, trees, and shrubs for sale. At this time, the nursery was located between two one-lane roads, seven miles from the Narrows Bridge. (Courtesy Tacoma Public Library.)

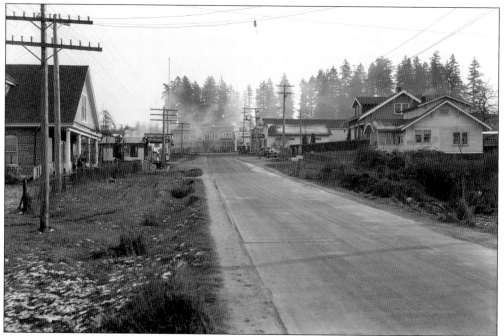

This 1957 view of Harborview Drive faces southeast and shows many residences that now have been replaced with commercial businesses. At the intersection at the end is the original Peninsula Café. (Courtesy Washington State Historical Society.)

Five

NARROWS BRIDGE

Tolls, whether for ferries or bridges, have always been of concern to Gig Harbor residents. This 1957 photograph shows the tolls for the first Narrows Bridge at that time. When the bridge was completed, there was little debate about the tolls, as it was so much more convenient and time-saving to take the bridge than to get on a ferry. When the bridge was new, everyone stopped at the tollbooth, and the toll-taker visually counted the number of people per car. Currently, tolls are $4, $5, or $6, and are paid either at the tollbooth, or, if a driver has a "Good-to-Go" pass, billed monthly. The fees instituted since the newest bridge was completed have caused many public meetings and heated discussions, because there had been no tolls on the bridge since 1965 and people had grown used to crossing for free. (Courtesy Tacoma Public Library.)

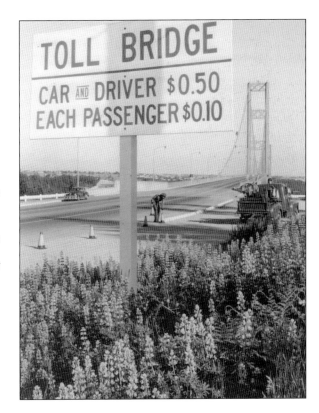

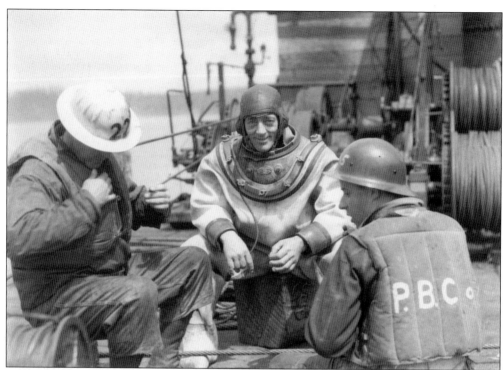

Johnny Bacon, in his 200-pound diving suit, prepares to enter the waters of the Narrows on May 12, 1939. Bacon dove to a depth of 90 feet during a slack tide, which was the only time it was safe for him to dive. Much underwater work was necessary to build the bridge. (Courtesy Tacoma Public Library.)

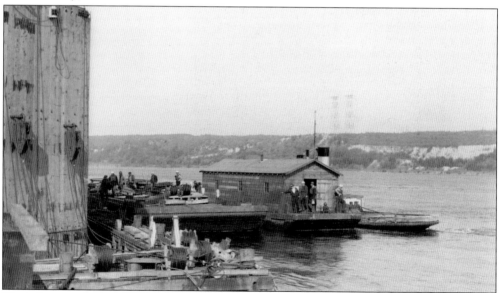

This photograph shows the west caisson of the Narrows Bridge under construction in April 1939. Point Defiance and the Bonneville power lines can be seen in the background. A catwalk surrounding the caisson floated up and down with the changing tides. (Courtesy Tacoma Public Library.)

This is an aerial view of the cement plant on the Gig Harbor side of the Narrows Bridge during construction in 1939. Note the lack of housing in the area at that time. (Courtesy Tacoma Public Library.)

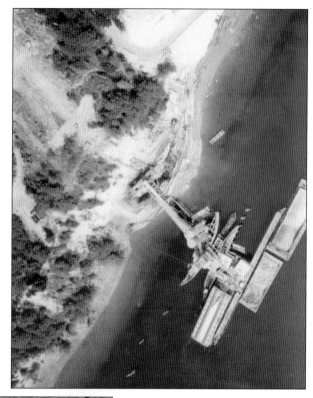

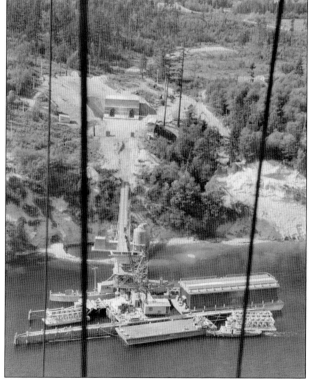

Looking down 400 feet from the west tower, this photograph shows the approach from the Gig Harbor side and the equipment that mixed the 111,380 cubic yards of concrete used in the pier construction. Cables can be seen in the foreground in this September 1939 photograph. (Author's collection.)

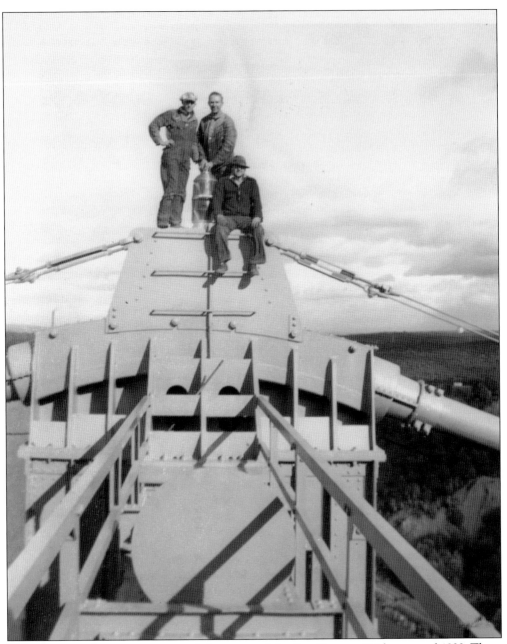

These brave workers pose atop one of the towers of the first Narrows Bridge around 1939. There are no safety harnesses visible for these three men, who are more than 400 feet above the water. (Courtesy Tacoma Public Library.)

An Official Event of Tacoma Narrows Bridge-McChord Field Celebration

DANCE! FROLIC! JUBILATE! CELEBRATE!

A FOUR-HOUR LAST FERRY-BOAT RIDE

Another Golden Jubilee on the "KALAKALA"

TUESDAY, JULY 2, 1940

LEAVE TACOMA MUNICIPAL DOCK, 8 P. M.

Sponsored by Tacoma Young Men's Business Club.

NO 757

ONE DOLLAR

From Tacoma to Bremerton via the Four Ferry Landings

LEAVING

Tacoma Municipal Dock,
8:00 P. M.

Pt. Defiance Ferry Landing,
8:30 P. M.

Gig Harbor Ferry Landing,
9:00 P. M.

—

Passengers Only—No Autos

Twice under the Bridge on the "KALAKALA"

UNLOADING AT

Gig Harbor Ferry Landing.

Pt. Defiance Ferry Landing.

Tacoma Municipal Dock.

—

Come in Costume If Possible

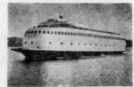

The Thrill of a Laughtime on the Last Ferry!

The "last ferryboat ride" prior to the opening of the new bridge in 1940 was aboard the *Kalakala*. This trip left the Tacoma Municipal Dock at 8:00 p.m., picked up additional passengers at the Point Defiance Landing, and arrived in Gig Harbor at 9:00 p.m. on July 2, all for a $1 fee. (Courtesy Tacoma Public Library.)

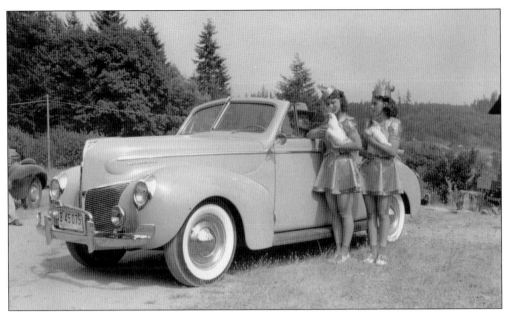

C.E. Shaw's rooster races were heavily promoted after the bridge was completed. Here, two women, holding roosters, are dressed in costumes and rooster hats to promote the upcoming races. (Courtesy Tacoma Public Library.)

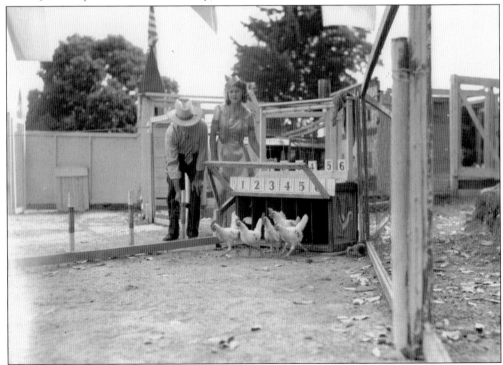

"Peninsula Day" was declared for July 2, 1940. Incorporating the Fourth of July, there were four days of celebrating the new bridge across the Narrows to Gig Harbor. Shown here is Gig Harbor promoter C.E. Shaw (left) and Beverly Hemley (right) opening the front of a cage to start the first rooster race of the day. (Courtesy Tacoma Public Library.)

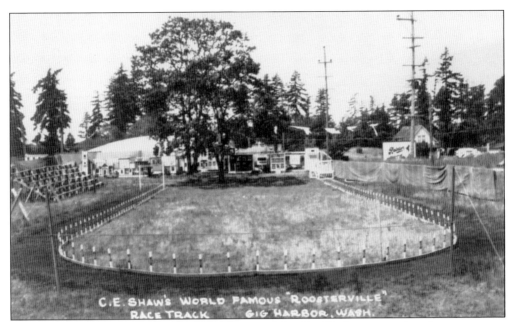

Shown here is the racetrack that C.E. Shaw used for Gig Harbor promotional rooster races. These races were eventually run in Madison Square Garden in 1938. (Courtesy Washington State Historical Society.)

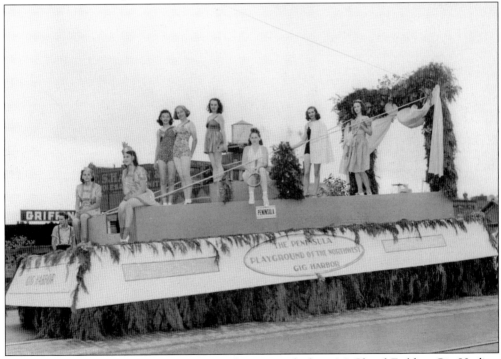

On July 1, 1940, over 60 floats participated in a parade from McChord Field to Gig Harbor, including the Gig Harbor float. The sign reads, "The Peninsula Playground of the Northwest, Gig Harbor." The float highlighted tennis and swimming among the activities available in Gig Harbor. (Courtesy Tacoma Public Library.)

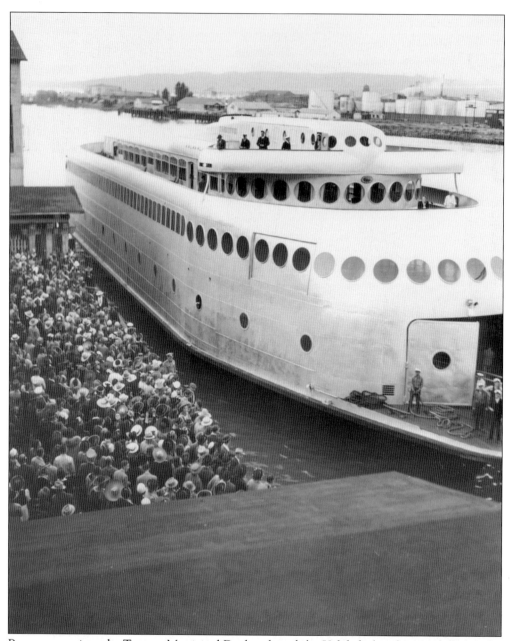

Passengers wait at the Tacoma Municipal Dock to board the *Kalakala* for what was billed as the "last ferry ride" across the Narrows on July 2, 1940. The trip, undertaken by 1,440 individuals, included costumes and a dance contest. (Courtesy Tacoma Public Library.)

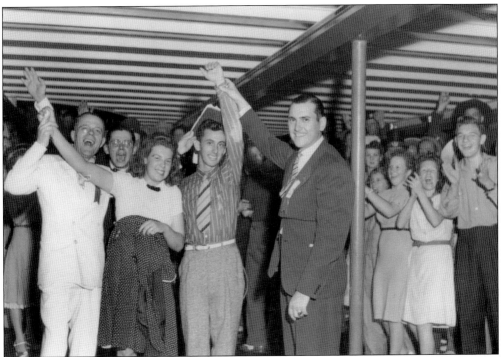

During the "last ferry ride" across the Narrows, passengers aboard the *Kalakala* lift the dance winners' arms in triumph. Among the evening's festivities, 15 prizes were awarded for dancing. (Courtesy Tacoma Public Library.)

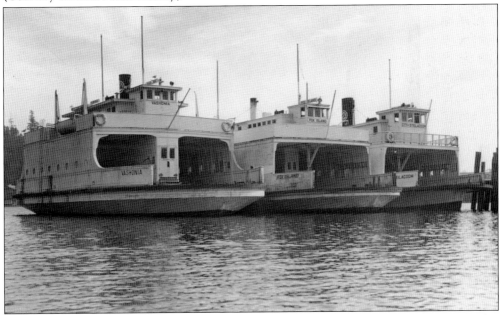

The *Vashonia*, *Fox Island*, and *City of Steilacoom* are moored shortly after the first Narrows Bridge was built. Their services became less needed following the building of the bridge. All three ferries were built by the Skansie Ship Building Company in Gig Harbor for the Washington Navigation Company. (Courtesy Tacoma Public Library.)

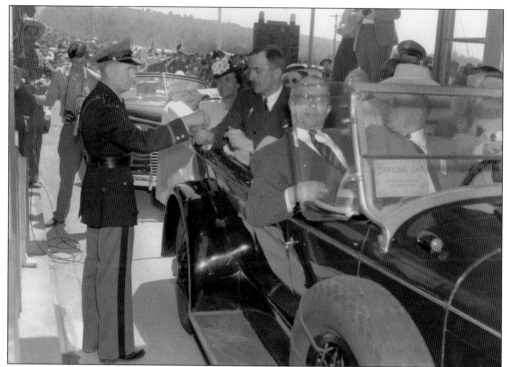

Gov. Clarence D. Martin, paying the toll, is riding in the very first vehicle to cross the new Narrows Bridge, on July 1, 1940. Norton Clapp, former chairman of the Weyerhaeuser Company, is in front of Governor Martin in the front seat of the 1923 Lincoln Touring Car. (Courtesy Tacoma Public Library.)

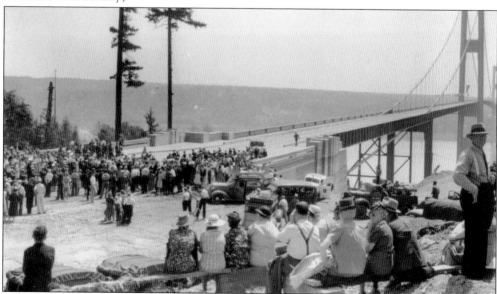

The crowd waits on the Gig Harbor side for the first automobiles to cross the new Narrows Bridge. Ribbons were cut on both sides to commemorate the event. It is estimated that about 7,000 people attended the ceremonies on both sides for the opening of this $6.4 million bridge. (Courtesy Tacoma Public Library.)

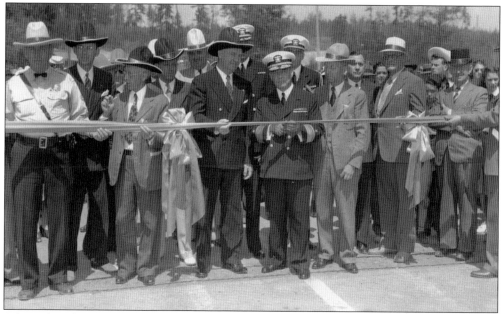

Adm. Edward B. Fenner, commandant of the 13th Naval District, is cutting the ribbon for the west side ribbon cutting of the Narrows Bridge opening ceremonies on July 1, 1940. To the left of the admiral, wearing the sombrero, is Bremerton mayor Homer Jones. There was no representation from Gig Harbor, as it was not yet a city. There was a separate ceremony for the east side of the bridge on that day. (Courtesy Tacoma Public Library.)

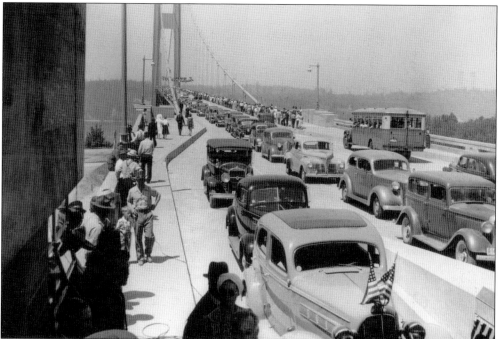

Here they come! These are the first cars returning from Gig Harbor upon the opening of the first Narrows Bridge. Regular traffic was unable to proceed until the lead car carrying Gov. Clarence Martin returned to the Tacoma side of the bridge. (Courtesy Tacoma Public Library.)

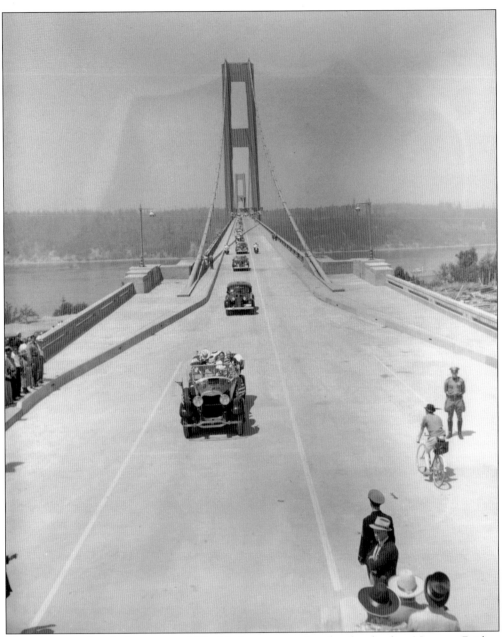

This photograph is looking toward Gig Harbor on opening day for the first Narrows Bridge. That day, 2,053 vehicles paid a toll to cross the new two-lane bridge. An unknown number of pedestrians enjoyed a toll-free opening day. Originally, pedestrians were charged 15¢ for each way they walked on the bridge. (Courtesy Tacoma Public Library.)

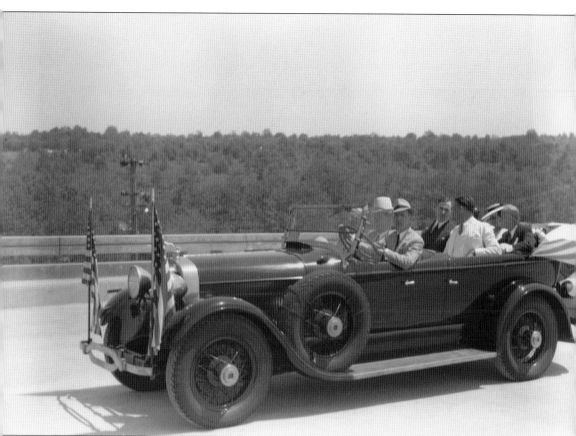

This 1923 Lincoln Touring Car was the first vehicle to pay a toll to cross the Narrows Bridge. It is shown here on July 1, 1940, carrying Gov. Clarence Martin (middle seat, dark suit), Norton Clapp (front seat passenger), and Tacoma mayor Harry P. Cain and his wife, Marjorie (rear seat). On previous occasions, Queen Elizabeth and Franklin Roosevelt rode in this automobile. As of this writing, the vehicle is on display at the recently opened Lemay America's Car Museum in Tacoma. (Courtesy Tacoma Public Library.)

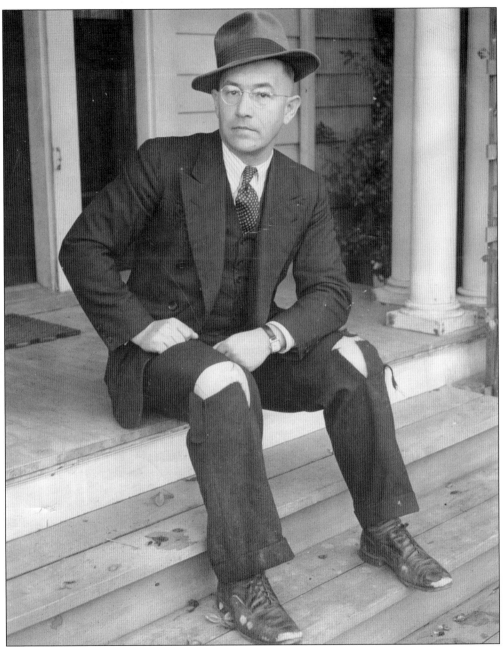

Leonard Coatsworth, a *Tacoma News Tribune* reporter, was the last person to drive on the Narrows Bridge before it collapsed on November 7, 1940, just three months after it was dedicated. While driving to his summer home in Arletta, he was caught on the bridge and had to make his way back to the Tacoma end on his hands and knees. He is shown here wearing the clothes he had on that day, marked with the tatters and tearing that occurred as he crawled back to safety. He lost both his automobile and his sister's pet dog, Tubby. (Author's collection.)

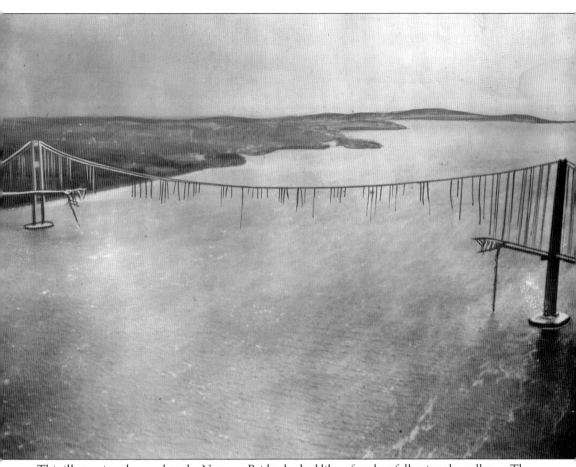

This illustration shows what the Narrows Bridge looked like a few days following the collapse. The view is from above Gig Harbor, looking east toward Tacoma. Day Island can be seen approximately mid-span, above the remains of the bridge. (Author's collection.)

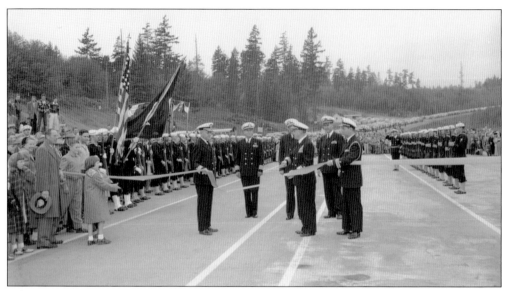

Adm. Daniel E. Barby cuts the ribbon for the second Narrows Bridge on October 14, 1950, just over 10 years after the first bridge was built. The second Narrows Bridge became the westbound bridge when the newest bridge was completed in 2007 for eastbound traffic. (Courtesy Tacoma Public Library.)

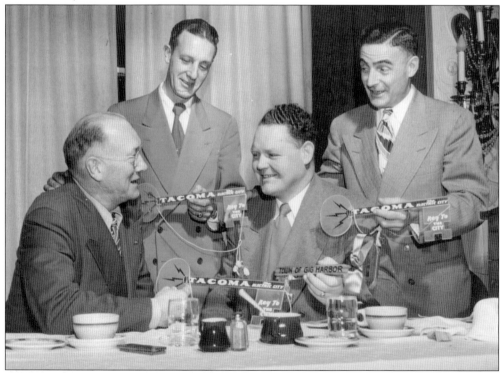

The mayor of Tacoma, John Anderson, is seen here accepting the key to the Town of Gig Harbor. He is surrounded by peninsula officials holding keys to the City of Tacoma. From left to right are Bremerton mayor L. Hum Kean, Kitsap County commissioner Verd Nichols, Mayor Anderson, and Gig Harbor mayor Harold H. Ryan. (Courtesy Tacoma Public Library.)

Six

NEWER GIG HARBOR

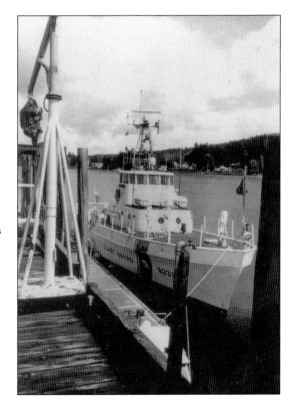

The US Coast Guard cutter *Point Glass* (WPB-82336) made its home in Gig Harbor from about 1971 to 1980. She was commissioned on August 29, 1962, and decommissioned on April 3, 2000. The boat was 82 feet, 10 inches long and had a beam of 17 feet, 7 inches. During the time she was assigned to Gig Harbor, her mission was law enforcement and search-and-rescue operations. While USCGC *Point Glass* was stationed in Gig Harbor, she was the only ship in southern Puget Sound available for these types of emergencies. (Author's collection.)

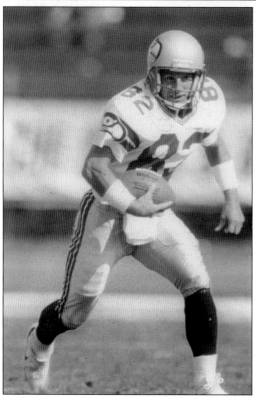

Paul Skansi began his football days at Peninsula High School, where he helped lead the Seahawks to the Washington state class AA championship with a record of 13-0. He graduated in 1978 and went on to play for the University of Washington, where he had been recruited by coach Don James. Skansi went on to play 10 seasons in the National Football League, including eight with the Seattle Seahawks (1984–1991). He caught 166 passes for 1,950 yards and scored 10 touchdowns during his NFL career. (Both, author's collection.)

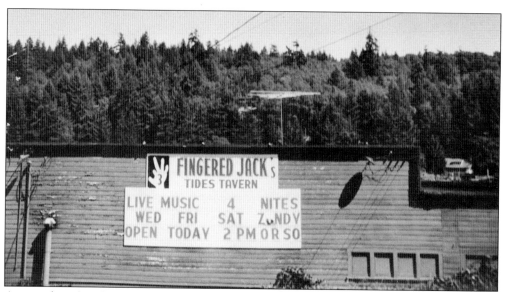

A sign identifies this establishment as "3 Fingered Jack's Tides Tavern." This was the Tides Tavern's name from 1969 through 1973, when it was owned and operated by Jack Hanover Miller. He had lost the first joint on his thumb, the first and second joints on his index finger, and the tips of the fourth and fifth fingers on his right hand in a gunpowder explosion on April 4, 1948. (Courtesy City of Gig Harbor.)

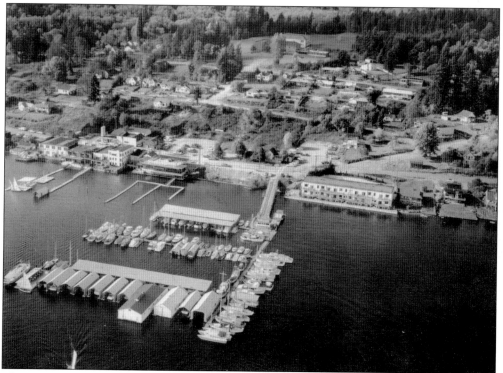

This 1967 aerial photograph shows the Peninsula Yacht Basin and the north end of Harborview Drive. The Shorline Restaurant, new at that time, is seen in the center with its own dock. (Author's collection.)

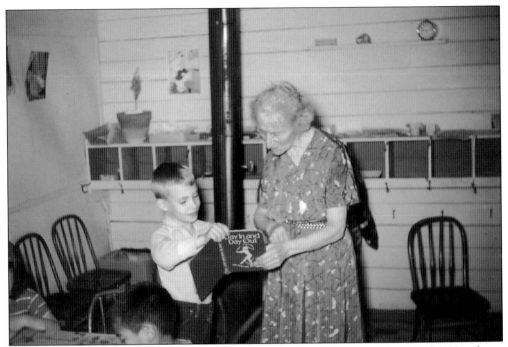

Al Mashburn and Lucille Goodman are seen above in her kindergarten classroom in 1959. Goodman taught school in Gig Harbor for a total of 76 years. She first retired from teaching in 1927, but continued as a kindergarten teacher. Her 1933 Chevrolet Sport Coupe, a fixture in Gig Harbor, is parked in front of the school where she taught kindergarten as a private tutor for many years. She finally retired in 1962. (Both, photograph by Harry Mashburn; courtesy Al Mashburn.)

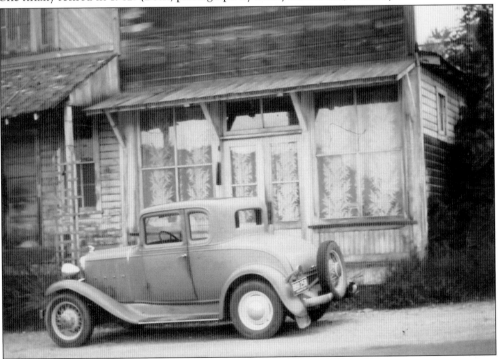

Robert Stauffer was the City of Gig Harbor building inspector from April 1981 until August 1983. (Courtesy City of Gig Harbor.)

This two-story, Tudor-style brick and stucco home on Harborview Drive, built prior to 1940, still stands today and looks much the same. One among several of similar design in Gig Harbor, it is currently used as a commercial building. (Courtesy Tacoma Public Library.)

Rev. Dr. Mark James Toone is shown here with his family shortly after taking his position as pastor of the Chapel Hill Presbyterian Church in July 1987. He remains the pastor as of this writing, having completed his 25th year of service. (Courtesy Chapel Hill Presbyterian Church.)

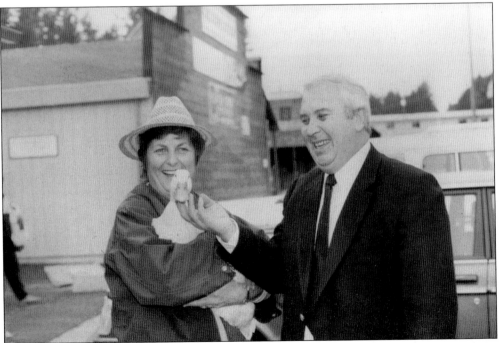

Gig Harbor National Bank president L. Anthony Tebeau meets Anne Marie Kanno in rural Key Peninsula, where a branch was established in 1986. Residents of the Key Peninsula brought in many of their farm animals for the bank's grand opening. (Courtesy Charles Perry.)

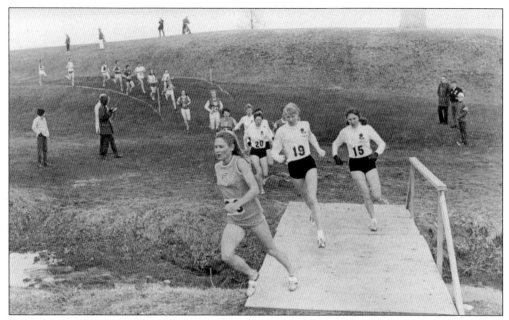

Doris Brown Heritage is shown winning her third International Cross-Country Championship race, followed by the English team. She graduated from Peninsula High School in 1960, before women were allowed to run on the school track. At one point in her running career, she held every woman's world record in running, from the 440-yard dash to the mile. She represented the United States in the 1968 and 1972 Olympic games and was inducted into the National Track & Field Hall of Fame in 1990. (Courtesy Doris Brown Heritage.)

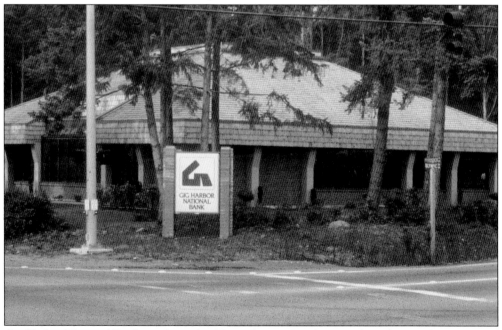

Gig Harbor National Bank was formed in November 1982 and operated until 1987, when it merged with Puget Sound National Bank. This building now houses Starbucks Coffee and a Keybank branch. (Courtesy Charles Perry.)

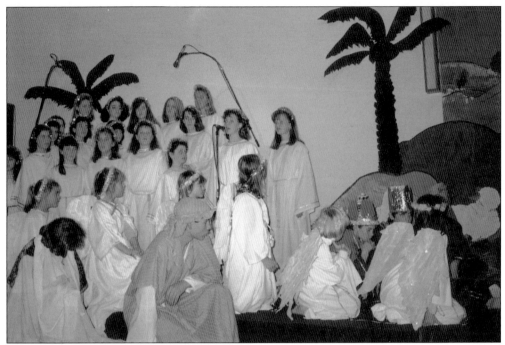

This photograph shows the 1986 Christmas pageant at the Peninsula Christian Fellowship Church in the early days of its new building. (Courtesy of Peninsula Christian Fellowship.)

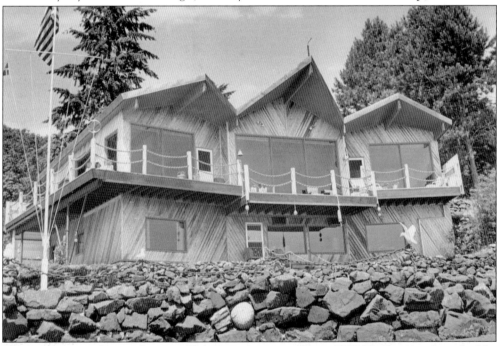

This 3,400-square-foot residence on Hale Passage is seen in June 1979. The home utilizes double-glazed windows, thick walls and ceiling, insulation, and many solar devices. It faces south on Wollochet Bay, with 655 square feet of glass to give the owners a 180-degree view. (Courtesy Tacoma Public Library.)

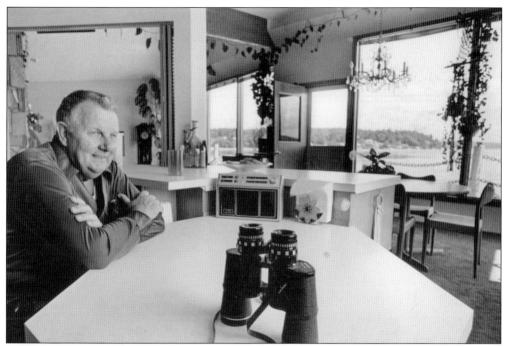

F.J. "Fritz" Beckman sits in his passive solar–power home on Hale Passage, shown on the previous page. In the late 1970s, he was able to heat the 3,400-square-foot home year-round without ever having a monthly heating bill over $60. (Courtesy Tacoma Public Library.)

Asta Thurston, wife of the first judge in Gig Harbor, watches with her grandson, David Winning, as the first water flows from the City of Gig Harbor well in 1948. This photograph was taken at the corner of Judson and Thurston Streets. (Courtesy City of Gig Harbor.)

The Eric Hayes Nursery is seen in this spring 1958 photograph. The nursery carried a wide variety of trees, shrubs, and garden supplies. Hayes's Dutch Colonial home had two stories, with a porch wrapping around the second floor. (Courtesy Tacoma Public Library.)

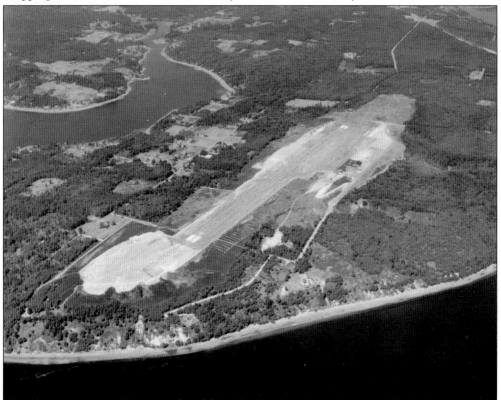

This 1966 aerial photograph shows what was at the time called the Tacoma Industrial Airport, on Point Fosdick. The airport is today called the Tacoma Narrows Airport and is operated by Pierce County. According to an advertisement in the *Tacoma News Tribune*, this airport had 35,728 takeoffs and landings in 1965. Note the distinct lack of development in the area at the time. (Courtesy Tacoma Public Library.)

This postcard was used by campers to send a note home from the YMCA Boy's Camp at Camp Seymour on the Key Peninsula. Each summer, hundreds of boys from Tacoma and Gig Harbor attended this camp on Glen Cove near Gig Harbor. At the time, only boys were allowed to attend. (Author's collection.)

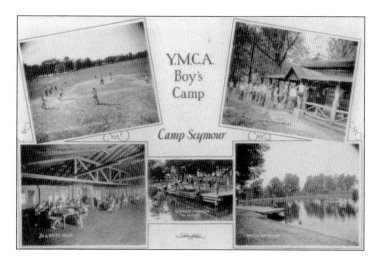

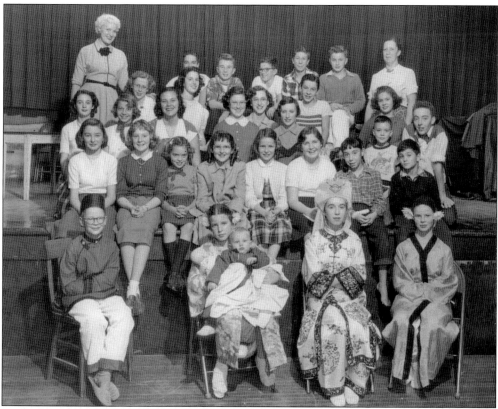

On December 1, 1951, the Peninsula Elementary Parent Teacher Association sponsored thespians in one-act plays held at the Gig Harbor Intermediate School. The children seated on chairs are costumed for *The Stolen Prince*. Among the children identified are Karen Coulter, Mary Beth Austin, Dorothy Ogden, Mariella Driskell, Judy Crabbe, Karen Mortenson, Gary Moore, Judy Hunt, Shirley Finholm, Judy Miller, Nola Austin, and Bobby Janes. The adult director for this play is Mrs. Melvin R. Mitchell, who stands in the last row at left. (Courtesy Tacoma Public Library.)

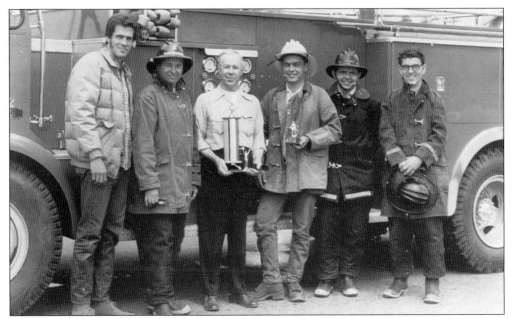

These Gig Harbor firefighters proudly display trophies won in a hose competition. From left to right are Bob Copeland, Drew Wingard, Chief Charlie Summers, Glen Stenbeck, Barry Stokke, and John Platt. This photograph was taken in 1969 or 1970. (Courtesy Gig Harbor Fire and Medic One.)

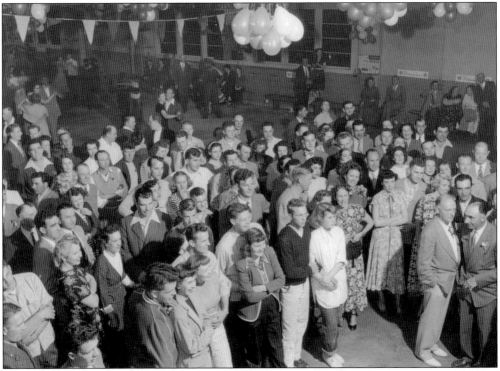

This was the scene at the annual Lions Club dance at the Rehn Motor Company in 1949. The annual event drew much interest in Gig Harbor and included a bingo night at the Chevrolet dealership. (Courtesy Tacoma Public Library.)

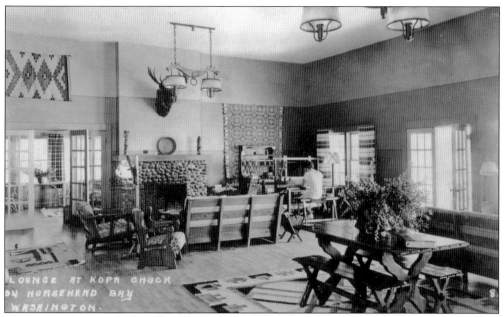

This postcard shows the lounge at Kopa Chuck Lodge (Kopachuck) on Horsehead Bay near Gig Harbor. Later, this would be located at Kopachuck State Park. The lodge burned down years ago and is no longer there. (Author's collection.)

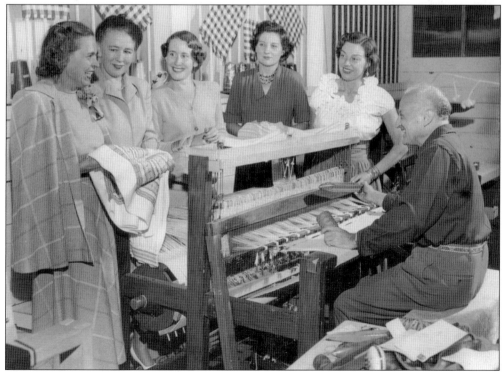

This is a studio at Kopachuck Lodge that was used for weaving, painting, and ceramics. The studio was open to the public. In this photograph, taken prior to 1950, the man is demonstrating weaving to a group of five women. (Courtesy Tacoma Public Library.)

A Peninsula Light labor crew poses for a photograph in 1953. Shown here are, from left to right, (first row) Walt Luters, Bill Parshall, Harold Smythe, and Glad Murray; (second row) Bob Hardy and Carl Veitenhans. (Courtesy Peninsula Light Company.)

These were the Peninsula Light Company rates effective in Gig Harbor on November 1, 1943. Peninsula Light serves over 26,000 homes and businesses over 112 square miles on the Gig Harbor and Key Peninsulas and is the second-largest cooperative in the state. (Courtesy Peninsula Light Company.)

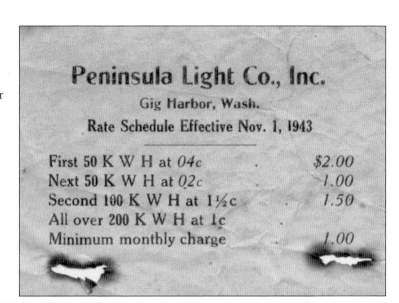

Peninsula Light Co., Inc.

Gig Harbor, Wash.

Rate Schedule Effective Nov. 1, 1943

First 50 K W H at 04c	$2.00
Next 50 K W H at 02c	1.00
Second 100 K W H at 1½c	1.50
All over 200 K W H at 1c	
Minimum monthly charge	1.00

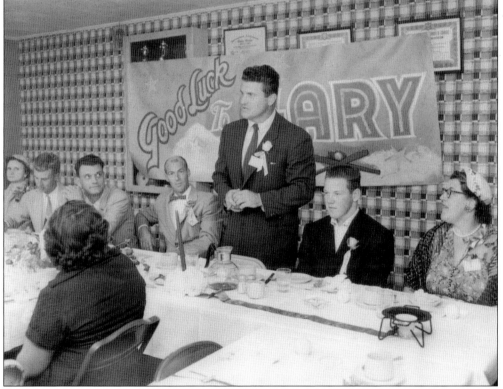

Peninsula High School baseball fans honor Gary Moore, seated second from left, at this special dinner on August 13, 1956, at the Shorline Cafe. Moore was named outstanding player in the State vs. City All-Star Game on June 15. He represented Washington state at the National Junior All-Star Game in New York. Moore had just been Peninsula High School's first four-year varsity athlete in baseball, basketball, and football. He entered the US Air Force and was awarded the Legion of Merit, two Bronze Stars, and 11 Air Medal Awards before he retired in 1981. (Courtesy Tacoma Public Library.)

Members of the Peninsula Christian Fellowship Church dance on the building's newly completed foundation in 1986. The cement had recently been poured and dried. Much of the church was built by volunteers from the congregation. (Both, courtesy Peninsula Christian Fellowship Church.)

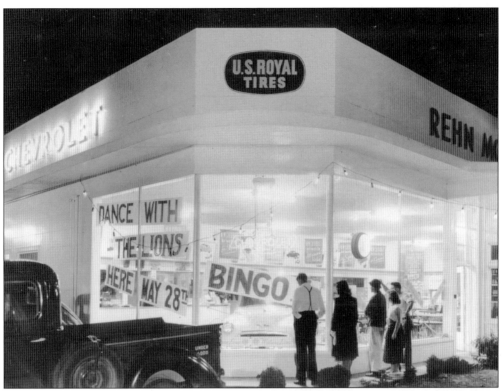

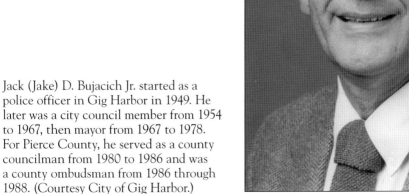

The annual Lions Club dance was quite an event around Gig Harbor. It was held at Rehn Motor Company before the new bridge was completed. Advertisements for the dance and bingo event adorn the windows as people look into the showroom on May 28, 1949. (Courtesy Tacoma Public Library.)

Jack (Jake) D. Bujacich Jr. started as a police officer in Gig Harbor in 1949. He later was a city council member from 1954 to 1967, then mayor from 1967 to 1978. For Pierce County, he served as a county councilman from 1980 to 1986 and was a county ombudsman from 1986 through 1988. (Courtesy City of Gig Harbor.)

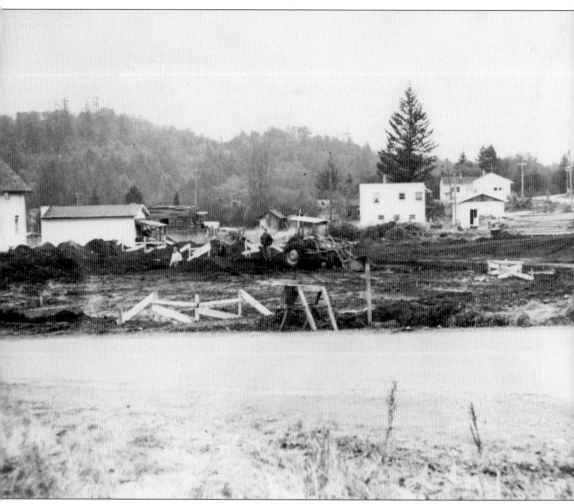

Crews prepare the site for the new medical-dental building on Pioneer Way in 1955. Doctors Charles Bogue and Del Lambing, along with dentists Harold Ryan and Richard Waller, were the owners of the new building. The small building on the right housed the first town water well, and the lot next door became the site of the first city hall, at 3105 Judson Street. The well house would eventually become the site of the present city hall in 1988. (Courtesy City of Gig Harbor.)

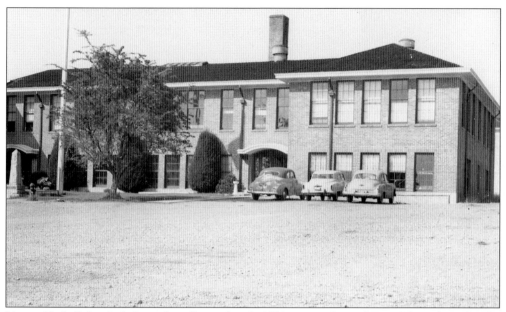

Union High School, dedicated on December 2, 1921, is seen here about 1950, judging by the cars parked in front. The World War II servicemen's memorial, erected in 1945, can be seen on the left. This school later became Goodman Middle School, then Harbor Ridge Middle School. (Courtesy Peninsula School District.)

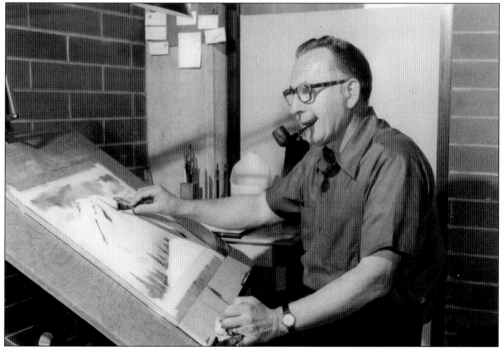

Kenn E. Johnson is shown at his easel on August 29, 1973. Johnson, the art and exhibit director for the Washington State Historical Society, lived in Gig Harbor at this time. This photograph was taken to publicize an exhibit of his artwork in the Tacoma Public Library's Handforth Gallery later that year. (Courtesy Tacoma Public Library.)

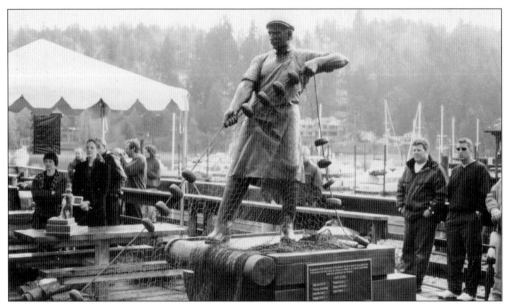

This photograph was taken at the dedication ceremony of Fisherman's Memorial. The installation, which was commissioned in memory of Gig Harbor's fishermen, is located in Jerisich Park. Among those observing the ceremony are Nick Babich (far right) and Andy Babich (second from right). (Courtesy Randy Babich.)

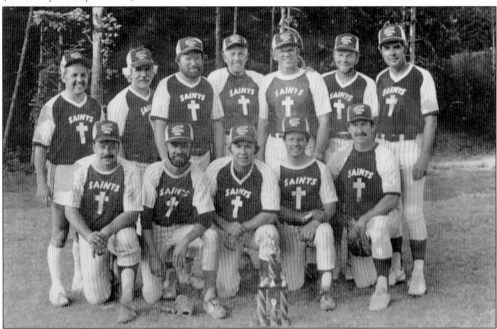

The Chapel Hill Presbyterian Church's baseball team, the Saints, poses for a photograph around 1983. From left to right are (first row) Lee Martin, Richard Booker, Philip Farmer, Thomas Jorgenson, and Jack Bresner; (second row) Michael Doherty, B. Eustice, Darrell Hedman, Lloyd Baker, Edward Conan, William Winters, and Richard Bowe. The Saints played from 1971 until 1983 and were formed by Lloyd Baker, who was the manager and pitcher. (Courtesy Chapel Hill Presbyterian Church.)

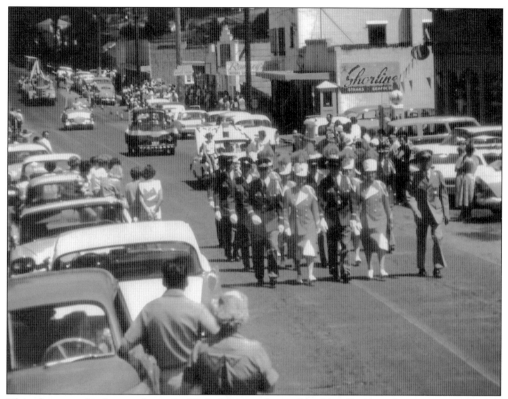

This photograph of a parade in the Finholm area shows the older Shorline Restaurant and other businesses of the time. It was taken during the annual Harbor Holidays Parade in June 1970. (Photograph by Harry Mashburn; courtesy Al Mashburn.)

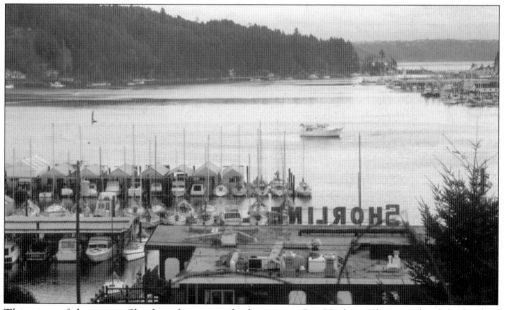

This view of the newer Shorline faces east, looking into Gig Harbor. The mouth of the harbor can be seen, with Point Defiance in the background. (Courtesy Charles Perry.)

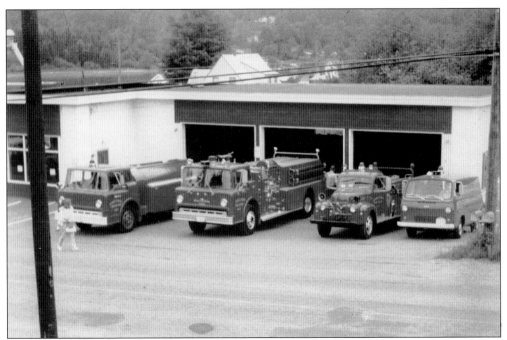

The Gig Harbor fire department's fleet of emergency vehicles is parked in the older fire station in 1968. Currently, at least 17 people are on duty at any time, staffing five stations of Gig Harbor Fire and Medic One. (Courtesy Gig Harbor Fire and Medic One.)

The old Thriftway store, shown here, eventually became the current Gig Harbor Post Office. This shopping center has recently experienced a turnover in most of its tenants, but the post office remains. (Courtesy Charles Perry.)

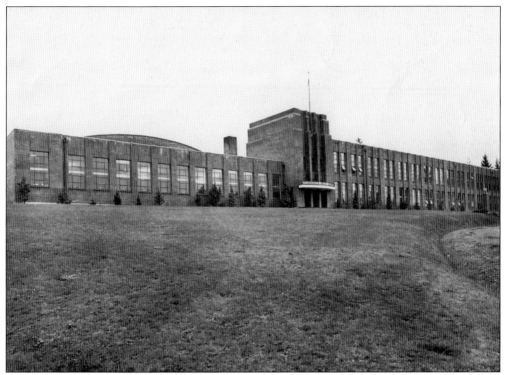

When built in 1947, Peninsula High School had only 13 rooms and a capacity for 250 students. Present enrollment exceeds 1,300 students, and there are 73 classroom teachers. (Courtesy Peninsula School District.)

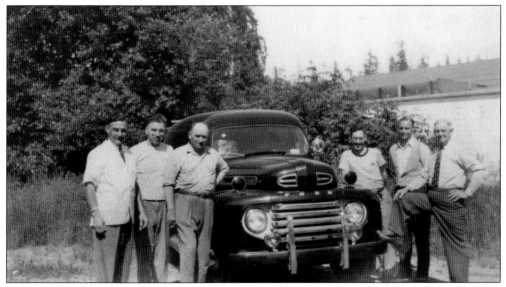

The Gig Harbor Police Department took delivery of its first patrol car in June 1948. Posing with the car are, from left to right, Mayor Harold H. Ryan, Councilman Antone Stanich, Judge Dick Thurston, Marshal Chester Jones, Councilman Keith Uddenberg, and Councilman Fred M. Perkins. The very first census of Gig Harbor, taken in 1946, listed 770 people. (Courtesy City of Gig Harbor.)

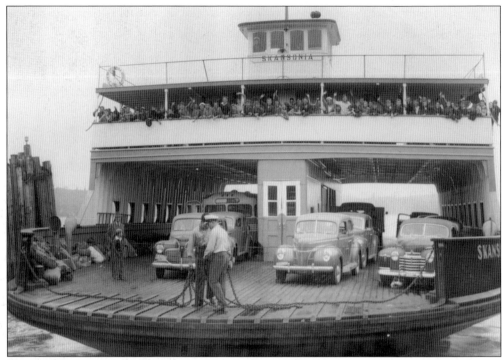

Tacoma Times newspaper carriers wave from the deck of the *Skansonia* as they return from a trip to Camp Seymour on August 16, 1945. They had earned the trip for selling newspaper subscriptions. The *Skansonia* was built in 1929 by the Skansie Ship Building Company and was used mostly on the Point Defiance–Gig Harbor route. (Courtesy Tacoma Public Library.)

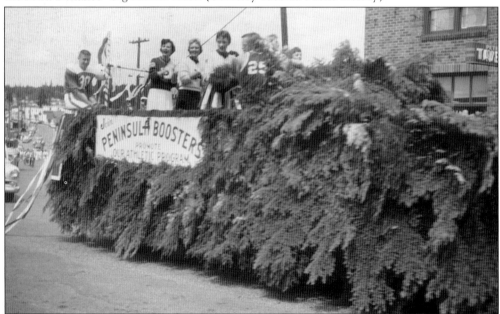

Peninsula Boosters ride on a float as the parade passes the Shell station, Pete's Tavern, and Charley's Barber Shop on Harborview Drive. This is an early Harbor Holidays Parade. (Courtesy Charles Perry.)

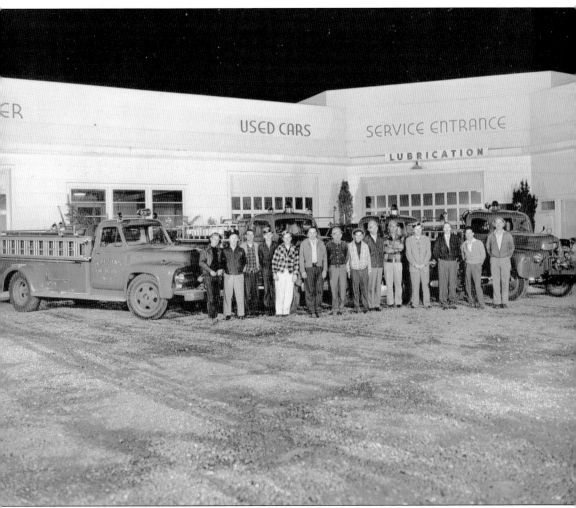

The Gig Harbor Fire Department's firefighters, trucks, and firefighting apparatus are shown on November 2, 1955, in front of Rehn's Garage. At this time, the Pierce County Fire District No. 5 was headed by Chief Charles L. Summers. (Courtesy Gig Harbor Fire and Medic One.)

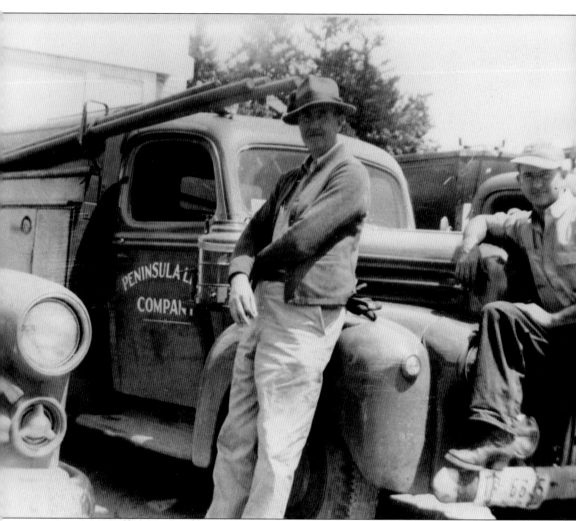

Howard Austin (left) and Loren Harriman pose with the Peninsula Light Company truck in 1953. They were linemen on the service crew. (Courtesy Peninsula Light Company.)

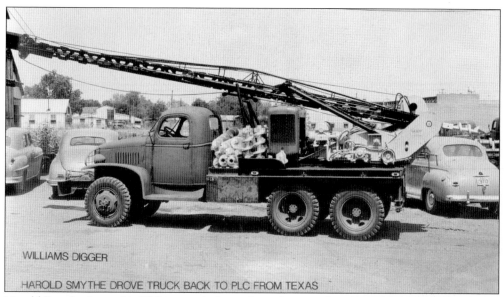

WILLIAMS DIGGER

HAROLD SMYTHE DROVE TRUCK BACK TO PLC FROM TEXAS

Harold Smythe drove this Williams pole digger from the manufacturer in Texas to Gig Harbor in 1950. Peninsula Light bought this piece of equipment in March of that year for $2,500. (Courtesy Peninsula Light Company.)

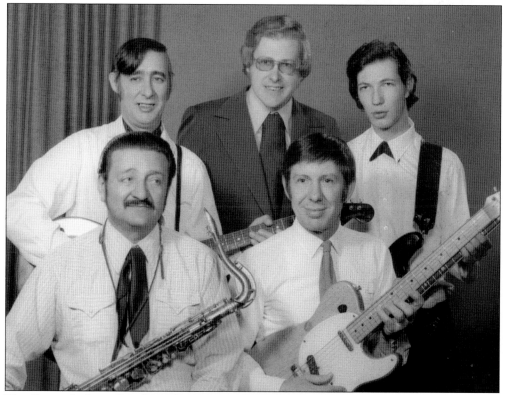

The Grover Jackson 4 performed country-western music and comedy at nightclubs throughout Western Washington. Jackson (first row, right) and his wife, Helen, made their home in Gig Harbor in the period around 1970. (Courtesy Tacoma Public Library.)

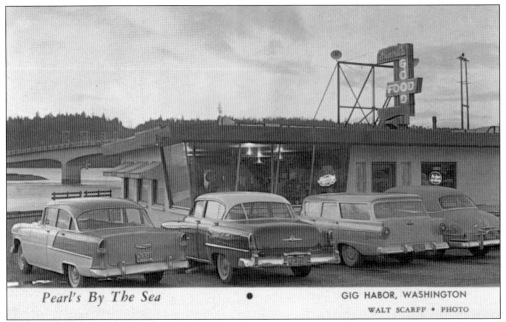

Pearl's By The Sea • GIG HABOR, WASHINGTON
 WALT SCARFF • PHOTO

This postcard shows Pearl's By the Sea as it appeared about 1950. Most Gig Harbor residents and people from miles around remember the special pies that Pearl, the owner, used to make. (Author's collection.)

The second Glencove School, on a hill near Key Center, was restored and converted into a residence, which was in turn recently extensively remodeled. Former students recently invited to visit the building could not believe how it had changed. (Courtesy Peninsula School District.)

A bulldozer in the middle of Donkey Creek engages in excavation work behind the original Peninsula Light Building, which was in use from 1925 to 1964. This is the approximate location of the present-day Harbor History Museum. (Courtesy Peninsula Light Company.)

A longtime favorite of boaters and residents of Gig Harbor, the popular Tides Tavern is seen here in an undated photograph. (Courtesy City of Gig Harbor.)

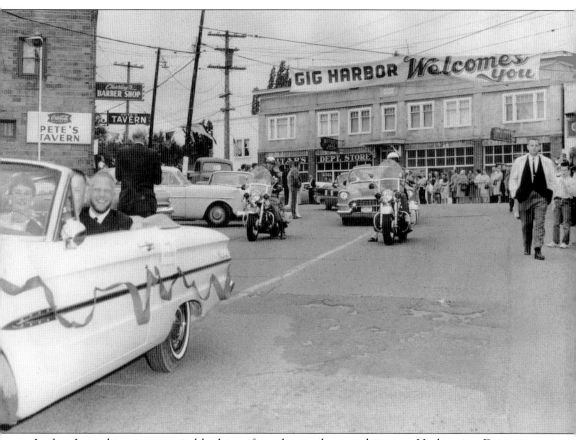

Luther Jerstad is accompanied by his wife and an unknown driver on Harborview Drive in Gig Harbor on June 26, 1963, following his triumphant climb to the summit of Mount Everest. Jerstad attended Peninsula High School, where his mother and father taught for many years. (Author's collection.)

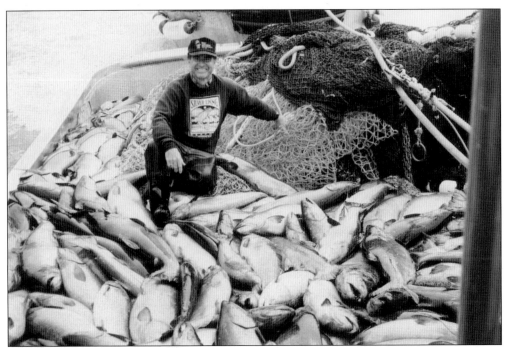

Fifth-generation Gig Harbor fisherman Randy Babich displays part of his significant king salmon catch in 1996. His boat, the *Paragon*, has made many trips to Alaska since he purchased it in 1980. (Courtesy Randy Babich.)

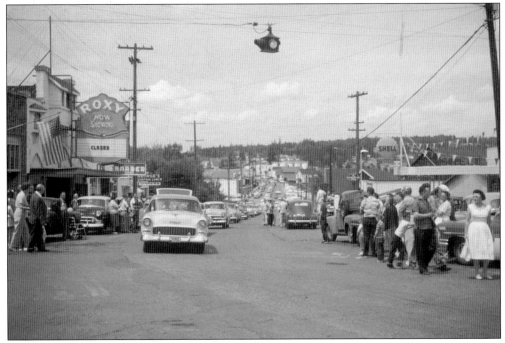

Harborview Drive in Gig Harbor shows activity before an upcoming parade. The Roxy Theatre, on the left, had recently closed and would soon be destroyed. Signs can be seen for George's Fountain Lunch, a barbershop, and the Shell station. (Courtesy Charles Perry.)

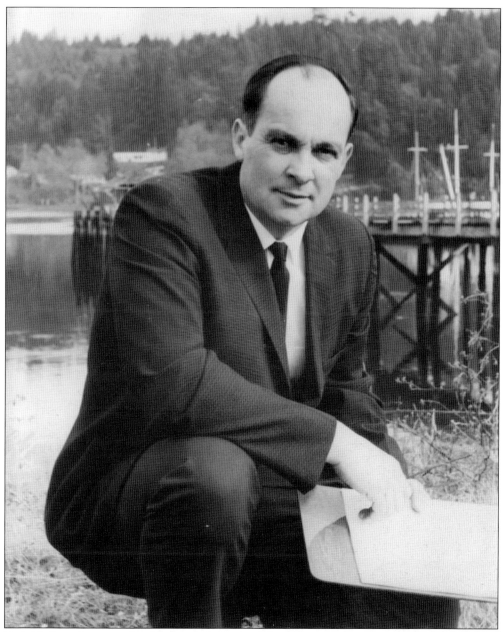

Nick Markovich was cited as "the spark that ignited the Congress of American Fishermen" by John Wedin, executive secretary of the organization, at a banquet in 1955. Markovich was a well-known Gig Harbor purse-seiner skipper. The issue that motivated Markovich and led to the honor was his concern about the Japanese threat to the Bristol Bay salmon resource. He was chosen to be the chairman of the Gig Harbor Planning Commission on April 5, 1962. (Author's collection.)

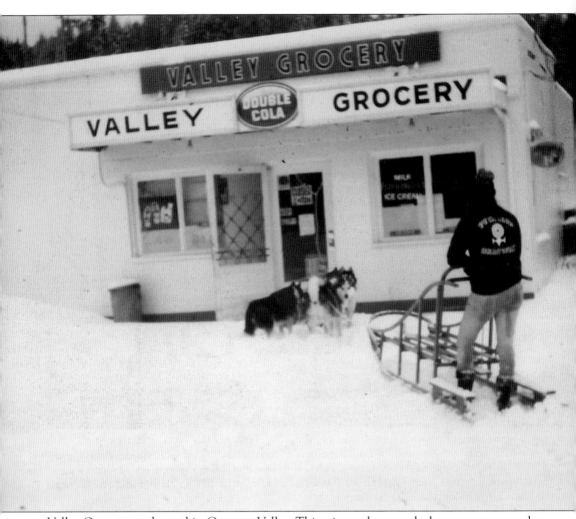

Valley Grocery was located in Crescent Valley. This winter photograph shows a customer who used a dogsled to get to the store. (Courtesy of Al Mashburn, Photo by Harry Mashburn.)

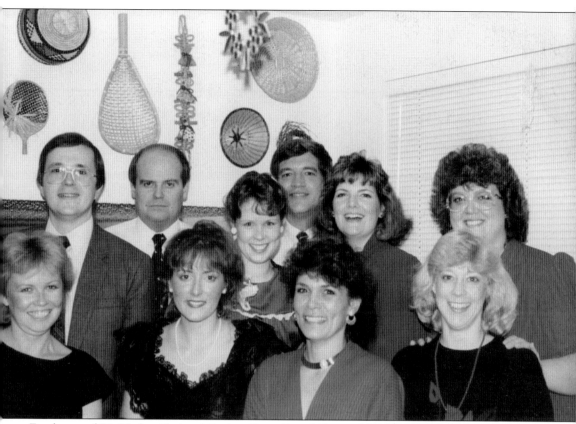

Employees of Gig Harbor National Bank or Puget Sound National Bank in Gig Harbor pose about 1986. From left to right are (first row) Bernice Vandegrift, Rachelle Cohen, Susan Nelson, and Debbie Komperda; (second row) Chuck Perry, Keith Petteys, Nina Casey, Don Tjossem, Cassy Sparks, and Leatha Camp. Gig Harbor Bank had a main office in Gig Harbor and one branch in Key Center. (Courtesy Charles Perry.)

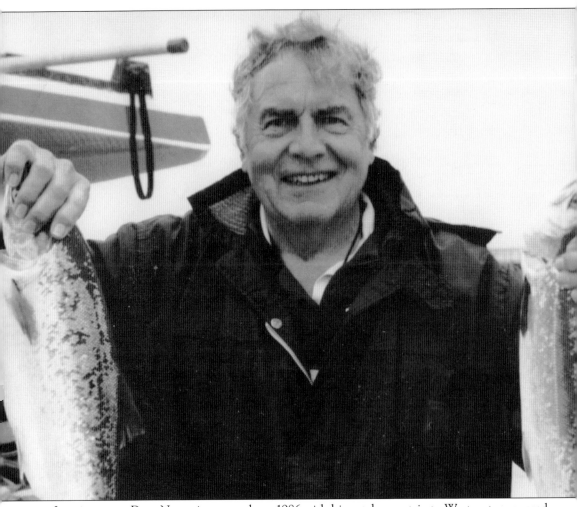

Interim pastor Dave Newquist poses about 1986 with his catch on a trip to Westport sponsored by the Chapel Hill Presbyterian Church. (Courtesy Chapel Hill Presbyterian Church.)

Bibliography

Eckrom, J.A. *An Excellent Little Bay: A History of the Gig Harbor Peninsula.* Gig Harbor, WA: Gig Harbor Peninsula Historical Society & Museum, 2004.

Evans, Jack R. *Little History of Gig Harbor, Washington.* Seattle, WA: SCW Publications, 1988.

Findlay, Jean Cammon and Robin Paterson. *Mosquito Fleet of South Puget Sound.* Charleston, SC: Arcadia Publishing, 2008.

Goodman Middle School students of 1974–1975. *Along the Waterfront: A History of the Gig.* Gig Harbor, WA: Mostly Books & the Peninsula Historical Society, 1979.

McDonald, Lucile. *Early Gig Harbor Steamboats.* (Based on the journals of Emmett E. Hunt.) Gig Harbor, WA: Mostly Books, 1984.

DISCOVER THOUSANDS OF LOCAL HISTORY BOOKS
FEATURING MILLIONS OF VINTAGE IMAGES

Arcadia Publishing, the leading local history publisher in the United States, is committed to making history accessible and meaningful through publishing books that celebrate and preserve the heritage of America's people and places.

Find more books like this at
www.arcadiapublishing.com

Search for your hometown history, your old stomping grounds, and even your favorite sports team.